Waltham Cross. TB XXII – c. A drawing from the tour of 1794 when Turner carried loose sheets of paper as well as sketchbooks

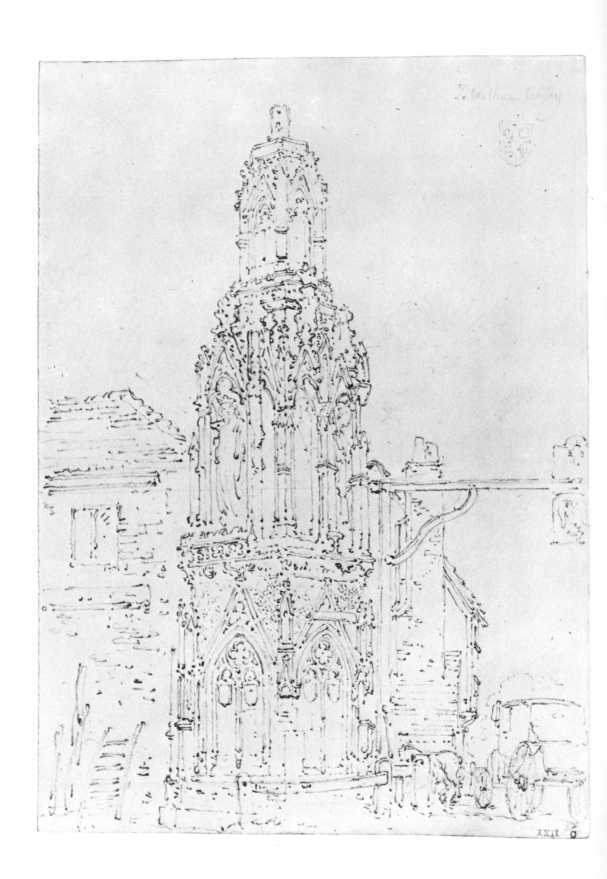

Turner's early sketchbooks

Drawings in England, Wales and Scotland from 1789 to 1802

Selected, with notes, by Gerald Wilkinson

Watson-Guptill Publications New York

Copyright © 1972 by Barrie & Jenkins Ltd, 2 Clements Inn
London WC2
Published in 1972 by Watson-Guptill Publications
165 West 46 Street, New York, N.Y. 10036
Library of Congress Catalog Card Number: 78-161198
ISBN 0 8230 5472 1
Printed in Great Britain

Explanation and acknowledgments

The sketchbooks and drawings of the Turner Bequest are preserved in the Department of Prints and Drawings at the British Museum. Nearly 20,000 items were arranged, numbered and dated by A. J. Finberg, whose *Inventory* was published by the National Gallery in 1909. Any work on Turner's sketches must first acknowledge Finberg.

In this book the catalogue number and Turner's or Finberg's title for the sketchbook appear at the head of each page. Very rarely I have ventured to alter Finberg's dates — but he could not be certain of many of them: being a scholar, he preferred concrete evidence to guesswork based on stylistic grounds.

Our running headlines therefore give the following information:

page]	*Turner Bequest (Roman) number of sketchbook*	*name of sketchbook*	*on first appearing page only: approximate year of sketchbook*	*size of page (vertical first) in inches and millimetres*

Finberg gave each separate drawing a letter and each sketchbook page, a number. Usually he numbered the leaves, so that the reverse sides are referred to as 1a, 2a, and so on: to avoid confusion these numbers are called *folios* in the text of this book. Each reproduced drawing has its folio or letter and either Turner's title, in italics, or the catalogue description. In some cases I have left the description out as being too obvious, or changed it where I thought it was wrong: but there should be no difficulty in identifying a particular drawing.

Turner's words, quoted from the sketchbooks, are all in italics.

The Keeper of Prints and Drawings and his assistants have given every possible help and facility to me and to the publishers, and to Michael Plomer, who undertook the exacting work of photographing the sketchbooks. These and other drawings and watercolours are the copyright of the British Museum unless stated otherwise under the reproduction.

I should like to thank Miss Parker of the Royal Academy Library for providing various prints, and a transparency of *Dolbadarn Castle*. Other institutions have either failed to reply to letters or charged rather heavily, making me all the more grateful for the liberality of the British Museum and the Academy — Turner would have approved.

Thanks to David Lloyd and to John Bunting for help, criticism and encouragement with the text and to Richard Wadleigh for the Index and for much care and patience in the whole production. John Welch of Colour Workshop also spared no effort in reproducing the often variable material. The typographical design and layout are my own and the reader can blame me for any difficulty in finding his way about. The *idea* came from Geoffrey Grigson.

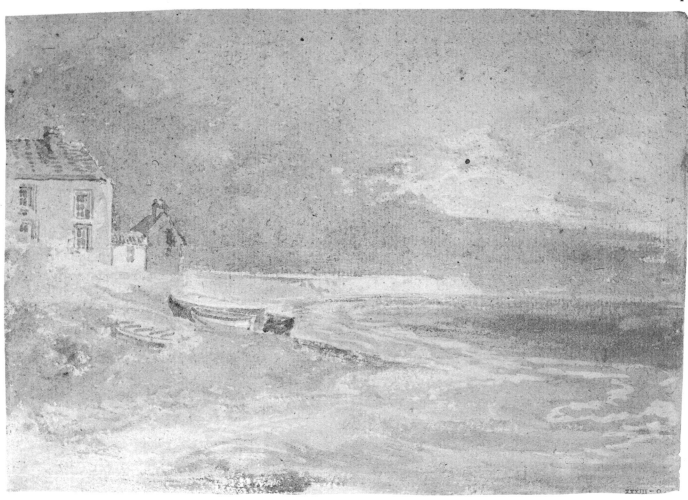

Near Folkestone? (TB XXXIII-O)
Turner's watercolour style around 1800

Preamble

Turner has marked our attitudes to landscape, particularly to
English landscape, in many ways that are not immediately
recognisable as his, and his only, so closely are they identified
with our ideas of what is picturesque, satisfying, or exciting.
Very few of the illustrations in this book have been reproduced
before, and the sketchbooks themselves cannot have been seen
by many people, yet again and again the pages seem familiar –
we seem to recognise not just the scene which is drawn but the
drawing itself. The fresh, no-nonsense style of the English
watercolour, whether of the nineteenth or twentieth century,
we find, is Turner's invention, not Girtin's, Cotman's or de
Wint's. The limpid perfection reached by all of these at their
best was not part of Turner's aim, but it was he who had the
exploring eye and it was he who first painted the weather.

But the image of Turner's work most implanted in our minds
is not that of the sensitive English watercolourist or topograph-
ical draughtsman. His early work has been neglected in the
past and was considered merely as a preparation for greatness;
his sketches have been largely unseen in this century. Those
pages that were shown in the nineteenth century were carefully
stuck back in the books once it was realised that they had faded
horribly. Most of the early 'finished' watercolours have suffered
this fate too, ending up brown all over, but this is no great loss,
except that, in many a provincial gallery, they militate against

The Golden Bough exhibited 1834. Detail (Tate Gallery)

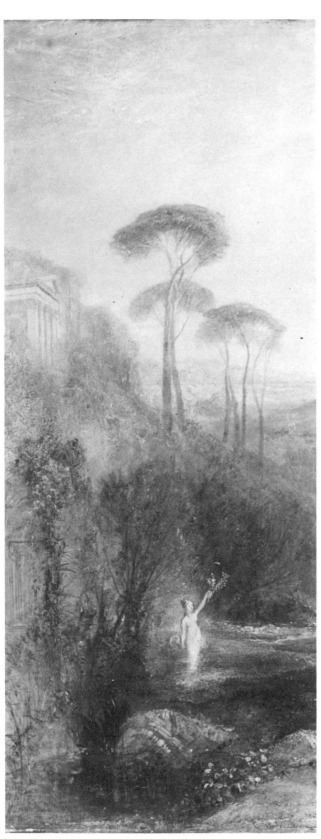

his reputation. A few of the more modern and abstract-looking sketches of his middle years are on view, as I write, at the Tate Gallery (under controlled lighting). Out of context they may baffle more people than they inspire.

We most of us think first of the lurid and impressive *Fighting Temeraire*, the magisterial *Rain, Steam and Speed*, the theatrical *Ulysses deriding Poliphemus*, or the pretty *Bay of Baiae* with its pair of Goyesque trees. Picture postcards from the Tate remind us of the mysterious and wonderful treatment of misty coloured light in his later oils. All pay him lip service – he is the only British painter to have a truly international reputation. Few would deny his claim to it.

Greatness is not the whole of Turner. The later oils are certainly great art, but they do not reveal the artist – indeed to our late-twentieth-century eyes they may seem to obscure him. It is as if we knew Beethoven only through the 'Ninth' and the last quartets, and perhaps *Fidelio*, and assumed that all he had done besides was the 'Moonlight Sonata'. The stature and the great message of Turner's work (as of Beethoven's) is in its completeness. From humble, if precocious, beginnings, careful imitation of his masters and diligent study of nature – and by sheer devotion and incredible application – he worked his way quickly to the top of his profession. He became a one-man *avant garde* in his twenties. Never tiring, never ceasing to observe and record and experiment, he then climbed way above the comprehension of his contemporaries, pushing his art and his never-failing skill to the farthest point to which the art of land-scape painting could be taken – anticipating half-a-dozen modern movements and leaving an immense body of work only a fraction of which can be called dated, in the way that the illustrative history paintings have dated.

The Turner Bequest

Turner's action in leaving all his unsold work, finished and unfinished, to the nation, has been seen by some as proof of self-admiration. But his ambitions were those of a simple, sensible man who was also a genius. He knew that he would not be properly appreciated in his own time, successful though he was. Pride or humility? Perhaps he guessed that he had been the victim of his times in some of his over-ambitious canvasses. It would not be in his nature to refute his worldly successes, but he did sincerely wish to be known by *all* his works, hence the Turner Gallery which was a condition of his will, now well implemented as far as paintings are concerned. His wish to be hung between two Claudes at the National Gallery certainly falls into the sin of pride, but that may be as far as it went. The Turner Gallery was intended to be separate, and built with his own money.

In the sketchbooks, which were part of this bequest, we see the artist working only for himself. There is no academic challenge, no unnecessary 'finish': here he escaped from the artistic conventions of the day – as did Constable in his equally personal sketches. The belief that work which is not designed for communication with the public cannot do so is now quite discounted. We are inclined nowadays to value sketches as highly as 'finished' work, even to the point where monumental works have been made from sketches blown up, with all their rough edges. In what have in the past been described as worthless scribbles we can now see Turner's masterly calligraphy: in the early, patient recording of Gothic buildings a masterly draughtsman-

A later sketch, about 1830 (Turner Bequest CCLXIII 87)
from a series exhibited at the Tate in 1971

ship. In the relatively few coloured sketches we can often
recognise a major advance in the use of colour or in the art of
picture-making long before it finds its place in a finished picture
– and what is so important, at the very moment of its inspiration
from the moods of nature. The studies in pastel for *Dolbadarn
Castle* are a startling example of this, the colours belonging more
to the 1830's than to 1799 – when the sketches must have been
done, for the relatively sombre painting was exhibited early in
the following year.

But I am no art historian and have no thesis to prove. I have
simply started at the beginning with an open mind – and a
touch of empathy – and selected the drawings that appealed to
me most (not always easy), bearing in mind the difficulty of
reproducing the fainter pencil work and attempting to include
something representative from each book. Most of Turner's
notes were in pencil, outlines which he could fill in from
memory – though many of them are entirely satisfactory as they
are. The pencil notes are in their hundreds, the monochrome
wash and the coloured pages in their fives and tens. We have
taken one or two from the hundreds and three or four from the
tens – it can't be helped.

The early sketchbooks as biography

Most of the 40-odd sketchbooks belonging to the first decade
of Turner's working life were small enough for a greatcoat
pocket: two or three are miniature. They went everywhere
with him on his travels in England, Wales and Scotland during
these years in which he progressed from apprentice draughtsman
to the leading landscape painter of his time – and incidentally
from barber's son to Royal Academician. At any stage on this

journey he might well have stopped and been satisfied. He could have lived well as a draughtsman of interesting antiquities and gentlemen's country seats. Five years later he could have chosen to be merely the world's best marine artist. Equally his reputation as a landscapist or as a historical painter would have been secure from 1800 onwards. But he had always greater things before him: we leave him in 1802 almost at the beginning, in terms of his career as a whole.

The story told by these pages is a good one. It is positive: failures are soon rectified, wrong directions given up; struggles are won and put behind. There is little drama; few sudden revelations and moments of excitement that are not put to good use. There are patches of boredom – concealing only Turner knew what anguish of endeavour – and some mystifying lapses. But Turner proceeds at his own pedestrian pace through these years of development: accurate, patient, devoted, not held back by bad weather nor put off his stroke by visions. By 1797 he knew his direction: he could leave topographical work and concentrate on pure landscape. But he continued to take on commissions for many years and made detailed notes of architecture until 1801, when he set himself to scale the heights of sublime or 'elegiac' landscape. In the following year he was made an R.A., but soon set off to see in all humility if Switzerland was as good as it seemed from Cozens' drawings and to improve his education at the Louvre, then full of all the 'old masters' looted by Napoleon. It was to be many years before his paintings lost the last touches of asphaltum, the main ingredient of what he called 'historical colouring', learnt from those well-varnished treasures. In the meantime the sketches reveal the artist as himself, not as the academic he wished to be and not as he appeared to be to his contemporaries. They show his ideas as they were conceived and not as they were modified, frozen, dressed up and presented (still outrageous enough) to the public.

In this book is about one per cent of the artist's total output of rough work and notes up to the point where Turner, R.A., aged 26, lands at Calais on his first trip abroad.

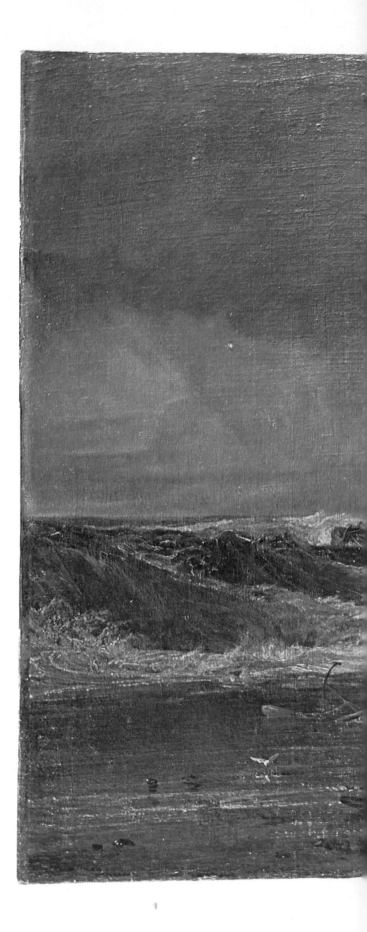

Fishermen upon a lee shore, in squally weather, 1802 (Iveagh Bequest, Kenwood, London). A major achievement of Turner's early years. Described by the *Star* as an 'admirable sketch, but we have doubt whether Mr. Turner himself could make it a good finished picture'. See pages 118, 119 and 144

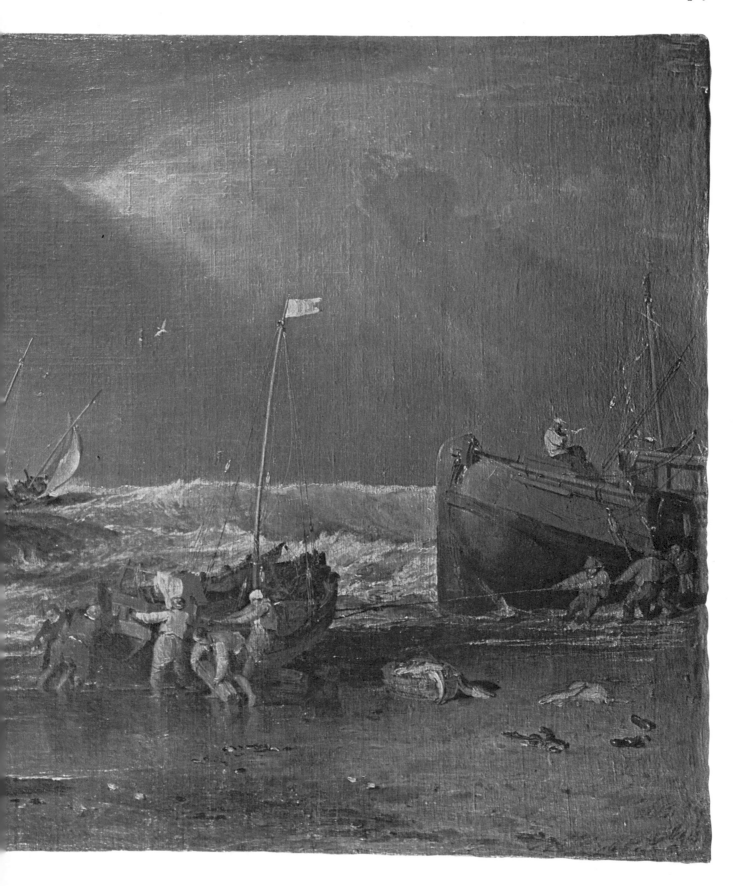

Almost certainly a portrait of Turner's mother, aged 55
(TB XX 35)

Turners' early life

Below are the proven biographical facts pertaining to the period covered by this book. Joseph Mallord William Turner was born on 23 April 1775 at 21 Maiden Lane, where his father was in business as a hairdresser. Maiden Lane is north of and parallel to the Strand, and is in the Parish of St. Paul's, Covent Garden. From one end of the lane you can still see the river, across the Adelphi Terrace.

Turner had a younger sister who died at the age of eight, in 1786. In the previous year the boy had been sent to stay with his mother's brother, a butcher, in Brentford, some twelve miles up the Thames. One of the earliest sketches to have survived is of Isleworth Church, near Brentford, and others were done around Abingdon, where his uncle had another house to which he retired. The earliest dated drawings are signed W. Turner, 1787; most of them are copies of engravings.

In 1789, aged 14, Turner was admitted to the 'Plaister Academy' at the Royal Academy Schools. The Academy was then in Somerset House. He had some instruction outside from Thomas Malton, but was not formally apprenticed to him. In 1791 Turner had two drawings in the Academy Exhibition – these are lost. In this year he started his second surviving sketchbook, at Bristol, where he stayed at the house in Broadmead of a family friend, John Narraway, a fellmonger and glue maker.

One of Turner's drawings was engraved in the *Copper Plate Magazine* in 1795. He continued each year to collect sketches in the summer and used the material for water colours he exhibited in the following spring. Many drawings were commissioned by publishers and by private patrons. About this time he began to work with Girtin in the evenings at Dr Munro's 'Academy', copying for 3s.6d a night and his supper.

In 1795 Turner's interests broadened to include an enthusiasm for the sea. He drew in Pembrokeshire and the Isle of Wight, and in 1796 his Academy exhibits included, for the first time, an oil painting: *Fishermen at Sea* – close to the Needles, by moonlight – now in the Tate Gallery.

In this year, 1796, he seriously applied himself to the study of composition and the search for subject matter for paintings, as distinct from topographical and architectural work.

In 1797 he went to the Lake District. At the next Exhibition, in the spring of 1798, he showed several important pictures, including *Morning among the Coniston Fells* and *Buttermere Lake*, with quotations from the poetry of Milton and Thomson. He sought (with much canvassing) election as an associate of the Royal Academy, but failed. He was elected in the following year at the age of 24 (1799). He now had a great many commissions and was being paid up to 40 guineas for a watercolour.

About this time he was in love with Sarah Danby, whose husband, John, a composer of popular music, had died in 1798, leaving her with four children. Sarah was an actress and singer. Turner's first daughter by her must have been born about 1800.

Turner, after some hesitation, left his parents' house early in 1800 and set up his studio at 64 Harley Street, Sarah's house being a few streets away.

At the end of this year Turner's mother was removed to Bedlam, and later discharged 'uncured'.

In 1800 or 1801 Turner made his first visit to the Highlands. Three Royal Academicians died, and Turner was elected to one of the vacancies in 1802. Shortly afterwards he set off for Switzerland.

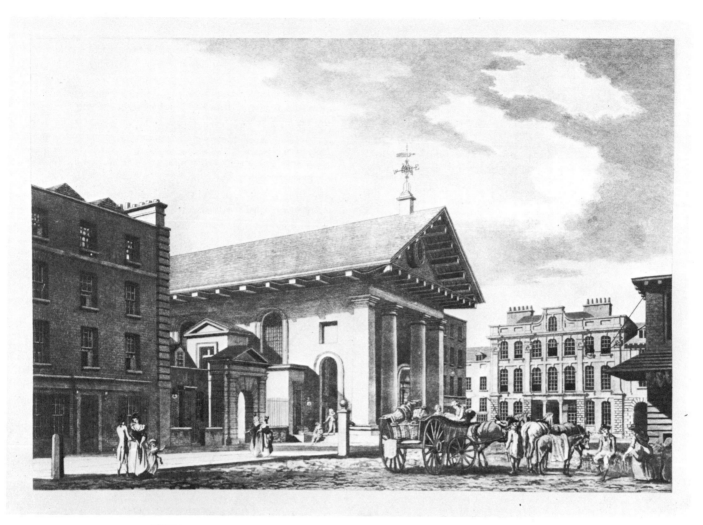

St Paul's Church, Covent Garden. Etching by Thomas Malton
from *A Picturesque Tour through the Cities of London
and Westminster*, 1792

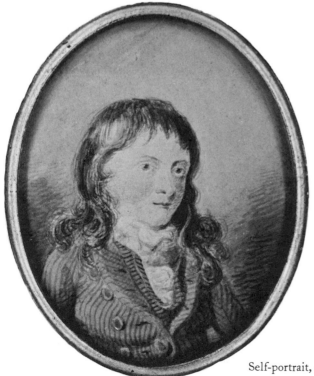

Self-portrait, aged 14 (National Portrait Gallery)

Monochrome copy of a sketch by J. R. Cozens, probably by
Turner or Girtin or both. From Dr Monro's collection, later
bought by Turner

A pencil drawing by Thomas Girtin, 1801.
The yard of an inn at Paddington. Detail

Girtin and Constable

Girtin was born in the same year as Turner and Constable was
a year younger. Comparison with both these artists is unavoid-
able, but must be limited for different reasons: Constable's
comparatively late development and Girtin's separate
educational path. Girtin and Turner worked together copying
drawings by John Robert Cozens and other artists at the house
of Dr Monro. Cozens was suffering from a 'total deprivation
of nervous faculty' (Farington) and in the care of the Doctor,
who had laid hold of his sketchbooks.

Turner's pencil manner in 1794 is practically indistinguish-
able from Girtin's, though they are not usually supposed to have
met until a year later. The rather pretty, hooked and dotted
pencil line they had in common seems to have come from
Guardi or Canaletto via Edward Dayes. It is not surprising that
similarities exist between the two: many of the Monro copies
can be correctly attributed to both of them – Turner is supposed
to have done the tones to Girtin's outlines. But Girtin and
Turner do not appear to have collaborated in more than this.
They seem to follow each other about the country in different
years, often choosing the same subjects and handling them in
very different ways. Turner's drawing is firmer than Girtin's:
his control of perspective is better. Altogether there is less in
common between them than might be expected. The reason is
that only for a time did they share the same aims (and this may
well have produced rivalry). Also, Turner was at the Academy,
Girtin was not: he was apprenticed to Dayes in 1789. Later
a number of artists and patrons had a hand in his training,
including Dr Monro, who tried to get him into the Academy
in 1795 – rather late in the day. Girtin's art education was in
fact scattered and casual compared with Turner's, but by
eighteenth century standards it was the more conventional. It
led him quickly into a dilettante circle and to early, if modest,
success – his work was engraved, for instance, two years before
Turner's. Farington records the words (in 1799) of certain
persons, 'disposed to set up Girtin against Turner, who they
say effects his purpose by industry – the former more genius –
Turner finishes too much'.

Girtin's ambitions were narrower than Turner's and he was
much more a conscious stylist. For this we may be thankful,
because in the last three years of his very short life (he died in
1802), he produced some small watercolours which it is hard
not to call perfect. His use of pencil, too, developed a degree
of sensitivity to which Turner never aspired – or if he did it
was in his misguided and rather *in*sensitive 'Scottish Pencils'.

Turner is on record as making some feeling remarks about
Girtin after he was dead: I think he missed Girtin's competition
more than his friendship and that, rightly, he respected him.

About Constable there is less to say here. At the period that
concerns us he was much more than the one year of his age
behind Turner in his development as an artist. He joined the
Academy Schools in 1799 and produced the early *Dedham Vale*
painting in 1801–2. At this stage he was no rival and he was an
admirer of Turner's when he was not being critical. He was a
very slow developer and seems to have waited for Turner's lead
even in his most characteristic method – the oil sketches.
Turner's were started in around 1806, Constable's in the
following decade. At a time when many young artists were
imitating Turner, Constable remained critical of his lack of

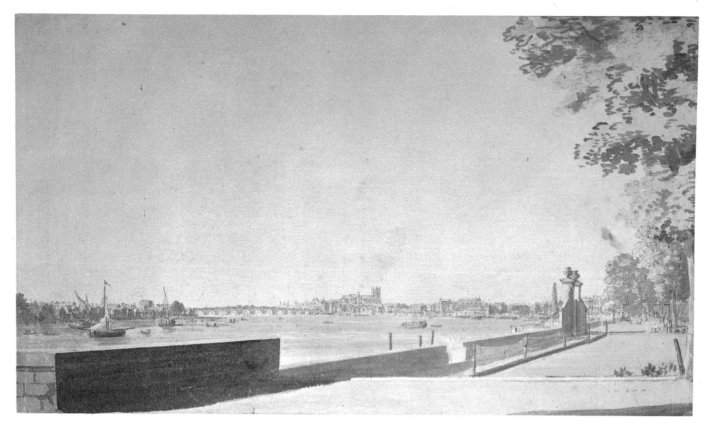

View of the Thames from Somerset House, by Paul Sandby

truth to nature. He does not seem to have spoken with Turner until 1813, when he wrote to his fiancee that Turner 'spoke as well as I had always expected he would'.

Turner at the 'Schools'

Turner's earliest drawings were on sale in his father's shop and were described as resembling Sandby — Sandby's influence would have been hard to avoid anyway: he was the pioneer of watercolour drawing in the earlier part of the century. Maiden Lane at that time contained at least two engravers and a picture framer, and the whole area of Long Acre and Covent Garden was full of artists of various sorts. Stothard was among the R.A.'s whom Turner's father shaved.

Thomas Malton was an architectural draughtsman — a competent one, but not of sufficient standing in the eyes of some Academicians to be elected to their number. Turner had some instruction from him but it is not clear whether this was before his time in the Academy Schools or at the same time. Malton probably coached the boy in perspective and the rudiments of architectural drawing. He almost certainly put in details and figures in Turner's early exhibited works, parts of which would seem to have been beyond Turner's ability then. Such a practice was not unusual — even Reynolds had an assistant for painting draperies. Perhaps the pleasant drawing of Lambeth Palace, often reproduced as Turner's first exhibited watercolour, should really be attributed largely to Malton.

Turner's introduction to the Academy Schools was through John Francis Rigaud, R.A. — a friend of his had seen some youthful drawings in Maiden Lane. Prospective students had to submit a drawing (or model) from a cast. If the Keeper — the resident R.A. supervising the Schools — and the Visitor — the Academician who was on duty that month — approved, then the student was 'permitted' to make another drawing from one of the Academy's collection of casts and this drawing was put before the Council to confirm his admission. Once on the books as a student he could remain so for up to ten years, as long as he attended reasonably. Students were expected to stick at drawing casts in the Plaister Academy until they were judged ready for the living model: but they had to be over 20 or married to be allowed to draw nude women. This, and a psychological tendency to avoid people, may explain Turner's early backwardness in figure drawing. There was no School of Painting at the Academy in the eighteenth century.

Turner was one of 22 students admitted in 1789. Of these only John Varley seems to have achieved fame. Varley's work does not suggest that he would have been a stimulating fellow student to Turner.

Turner worked in the Plaister Academy fairly regularly from 1790 until October 1793 (Finberg, p 19). The Register of the Academy schools for 1793 shows that Turner attended life classes on nearly every evening from January 10 when the schools reopened after the Christmas vacation, to March 25 when they were closed for the Exhibition. On March 27, 1793 he was awarded the 'Greater Silver Pallet', for landscape drawing, by the Society of Arts.

He continued to attend the life classes intermittently until 1799.

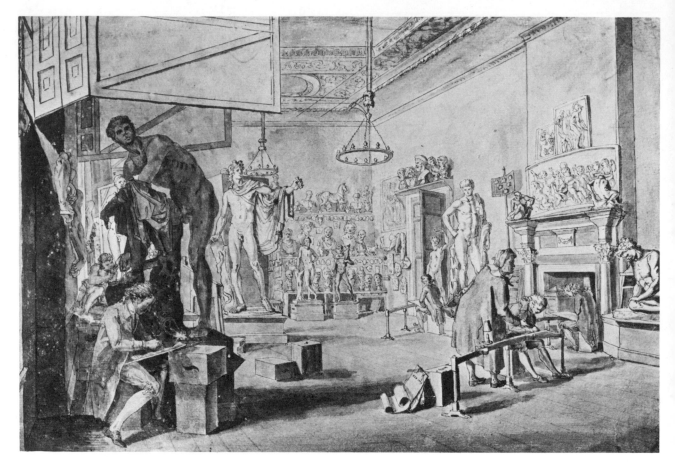

The Plaister Academy: *The Antique School at Old Somerset House*
by E. F. Burney, 1779 (Royal Academy)

Turner's masters

Nine Visitors, Academicians, one for each month of term time,
were appointed each year to teach the students. As a student
at the Academy Turner was in a position to benefit from
the best of London's artists, though he seems to have struck an
unfortunate patch in the Schools' history, even if he did hear the
last of Reynolds' Discourses. The Keeper (in charge of the
Schools) was Joseph Wilton, an aged sculptor and a founder
member. Having allowed discipline to relax he apparently made
desultory attempts to regain control by depriving the students
of bread (crumbs were used for rubbing out, and misused as
missiles) and by getting the Professor of Painting the sack. This
was James Barry, a dissentient who had not exhibited for years
and was accused, like art school staff in latter years, of criti-
cising the administration in front of the students. I don't think
Turner would care for this – he was too keen to get on, and
anyway he always loved the Academy.

Fuseli took over the Professorship in 1799, by which time
Turner was an A.R.A., though still an earnest student of figure
drawing.

Other eminent Academicians were Paul Sandby, then in his
seventies, but evident as an influence on the juvenile Turner:
George Dance, Professor of Architecture from 1798, who in-
cluded Turner in the series of sensitive drawings he did of the
members and associates (see page 109): Hoppner, who advised
Turner in 1798 against 'tending too much to the brown'. Good

advice, support, and no discouragement were there for Turner.
Even the carping Sir George Beaumont appears to have been
silent until after Turner became successful. Benjamin West, the
American who became President after Reynolds' death in 1792,
was too busy being dignified and having audiences of the King
(George III) to bother about a young student. Joseph Faring-
ton, an unoriginal painter, was friendly, if uncommitted – and
did Turner, and us, the service of recording in his *Diary* most of
what we know of Turner's early life. He also picked Turner's
brains about Welsh scenery and 'absorbing' grounds. Edward
Edwards was Turner's Teacher of Perspective. Edwards was
only an A.R.A., and therefore not a professor.

Of the founders of Romantic watercolour, Cozens' work was
known to Turner, as was, probably, Francis Towne's. The
Swiss, Philip de Loutherbourg became an R.A. in 1781.

More insight than mine would be needed to isolate the real
passions which moved the younger Academy painters in the last
years of the 18th century. Salvator Rosa was still on a pedestal,
as high as Poussin's and Claude's. Van der Neer and Joseph
Wright of Derby might both have inspired Turner to choose
moonlight for his first (known) attempts at oil painting. (Joseph
Wright was an exhibitor, an A.R.A. who had been elected to
membership but had failed to submit his Deposit picture.) The
Dutch of the previous century were looked on as masters: Cuyp
was much collected and the Van der Veldes, the great sea
painters, had worked in England.

But it was Richard Wilson (died 1782) whom Turner vener-

Edward Edwards, Teacher of Perspective at the Royal
Academy, 1788–1806, drawn by himself. Edwards was
succeeded by Turner as Professor of Perspective

ated in landscape, until he faced the challenge of Claude in 1799.
He knew something of Poussin before he went to the Louvre
and he was as interested as everyone else in the antiquities of
Egypt which were then being explored by the many educated
amateurs serving there in the expeditionary forces. There was a
craze for everything Egyptian in London around 1800 and
Turner's 'Plague' pictures were part of this, though in them he
does not seem to have assimilated much of the peculiar magic of
that romantic chapter in archaeology – Poussin is uppermost.

Painters at this time had nothing like the wealth of public
art that we enjoy (or are confused by) and they had reproduc-
tions more unsatisfactory than ours and in much smaller
quantity. Foreign travel was impossible until after the Treaty of
Amiens in 1801. But there were some fine private collections
and there is no knowing what a determined young man might
have got to see – and whatever Turner did see, we may be sure
he looked at carefully.

Wordsworth's and Coleridge's *Lyrical Ballads* were pub-
lished in 1798 but perhaps were too new for Turner – Thomson
in his *Seasons* was Turner's guide to the poetry of landscape.
James Thomson's monumental poem of over 5,000 lines,
completed in 1746, was the bible of the romantic painters. It is
rich in visual imagery and colour, often clumsy and naive, but
always dynamic. The language, though verbose and irritatingly
circumlocutory, has a certain muscularity of texture (Thomson
was a Scot). Here is a passage from 'Winter' which must have
appealed to Turner.

Muttering, the winds at eve, with blunted point,
Blow hollow-blustering from the south. Subdu'd,
The frost resolves into a trickling thaw. 990
Spotted the mountains shine: loose sleet descends,
And floods the country round. The rivers swell,
Of bonds impatient. Sudden from the hills,
O'er rocks and woods, in broad brown cataracts,
A thousand snow-fed torrents shoot at once;
And, where they rush, the wide-resounding plain
Is left one slimy waste. Those sullen seas,
That wash'd th' ungenial pole, will rest no more
Beneath the shackles of the mighty north,
But, rousing all their waves, resistless heave.
And, hark! the lengthening roar continuous runs
Athwart the rifted deep: at once it bursts,
And piles a thousand mountains to the clouds.
Ill fares the bark with trembling wretches charged,
That, tossed amid the floating fragments, moors
Beneath the shelter of an icy isle,
While night o'erwhelms the sea, and horror looks
More horrible. Can human force endure
Th' assembled mischiefs that besiege them round?
Heart-gnawing hunger, fainting weariness,
The roar of winds and waves, the crush of ice,
Now ceasing, now renew'd with louder rage,
And in dire echoes bellowing round the main.
More to embroil the deep, Leviathan
And his unwieldy train, in dreadful sport,
Tempest the loosened brine, while thro' the gloom,
Far, from the bleak inhospitable shore,
Loading the winds, is heard the hungry howl
Of famish'd monsters, there awaiting wrecks.
Yet Providence, that ever-waking eye, 1020
Looks down with pity on the feeble toil
Of mortals lost to hope, and lights them safe
Through all this dreary labyrinth of fate.

'Tis done! Dread WINTER spreads his latest glooms,
And reigns tremendous o'er the conquer'd year.

There were at the time some more ephemeral writings on land-
scape and art, following the fashion started by Edmund Burke's
Philosophical Investigation into the Sublime and Beautiful.

Turner worked hard. He used his friends, saved his money,
preferred places to people. He was not prepossessing to look at
and had few manners. All this has been emphasised by his
biographers. But he had a father who, he said, never praised him
except for saving a shilling, a mother who went mad; his sister
had died. He was much away from home as a boy. He was
perhaps no more lonely than most young artists who really are
artists, but it cannot be said that he had enjoyed a particularly
happy upbringing or an elegant education. He *was* good
humoured – 'one could not help but like him', wrote a friend of
the Narraways, expressing an otherwise poor opinion of him,
and there are many records of his cheerfulness in difficult
conditions.

The character which emerges is that of an amiable egocentric,
a young man obsessed with whatever he had in hand, whether it
was to improve his art or his position. He was ambitious, but
careful too.

4 A house near Abingdon

24 A copy

21 Malmesbury Abbey

24 View from Cook's Folley (detail)

The first sketchbooks

Turner's first sketchbook, number II in Finberg's catalogue, was used in Brentford and near Abingdon. The boy practised his perspective in drawings of Radley Hall (on the Oxford side of Abingdon) and he recorded from the Abingdon road his 'first view of Oxford' – a smudgy but accurate view which he later turned into a more impressive, less accurate watercolour. Some copies of coloured engravings – the best models he could get – are touching in their immense distance from our own world, carefully preserved as they have been by the great painter, his executors, and the curators of our museums.

Folio 4 is the most attractive of the drawings. Turner has managed to convey the feeling of an untroubled summer morning passed in studying the effects of light and shade on this pleasant house.

Two years later, staying at Bristol, Turner spends a lot of time on the cliffs above the Avon – his first experience of wild or rugged scenery. Here also are his first ships, carefully detailed as always. The drawing of Malmesbury Abbey shows him already well started on his early career in the Picturesque.

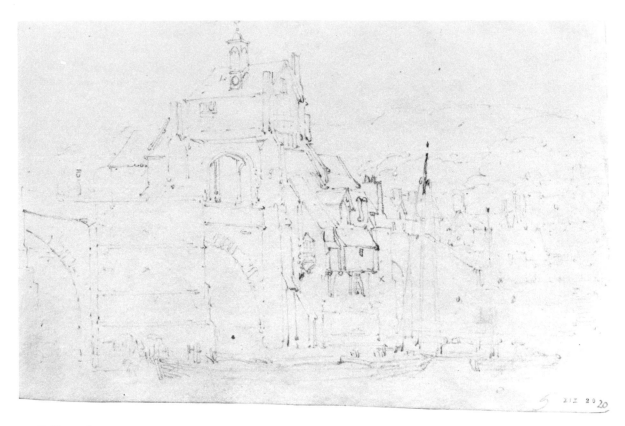

20 Bridgnorth

19 Bridgnorth

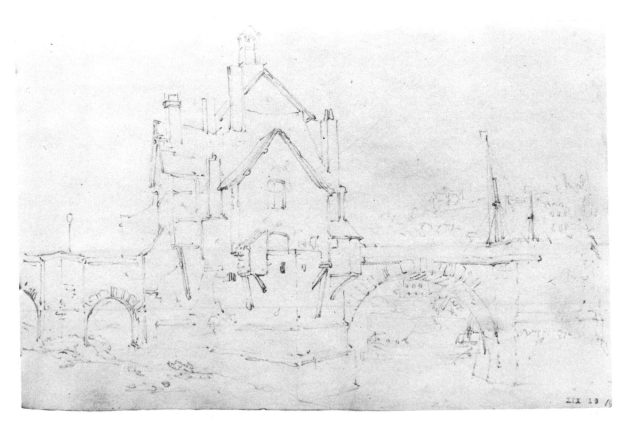

Engravings from the *Copper Plate Magazine*, 1795

The Midlands

When Turner next used a sketchbook he was on his first tour to collect topographical material. Besides the two small notebooks he carried loose sheets of paper. He used pencil all the time in the notebooks except for one page (folio 43) where some simple washes of grey and ochre, and blue now faded, are enough to make the towers of Lichfield shine out mysteriously – a moment of discovery.

In this book full of pencilwork, the style is direct – no sketchy hesitation, thanks to the years in the Plaister Academy. The hooked and dotted lines are reminiscent of Girtin, or perhaps of Dayes, who was Girtin's master. But the drawings are outlines, not complete statements, and this makes the sketchbook rather unsatisfying to look through. There is also an element of quaintness: at nineteen Turner's taste had not quite developed.

The first pages of this 'Matlock' sketchbook are filled with details of places to visit and, methodically, the mileage between them.

21 A market

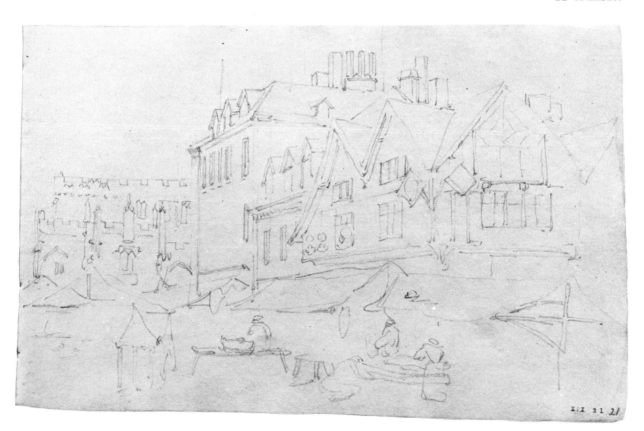

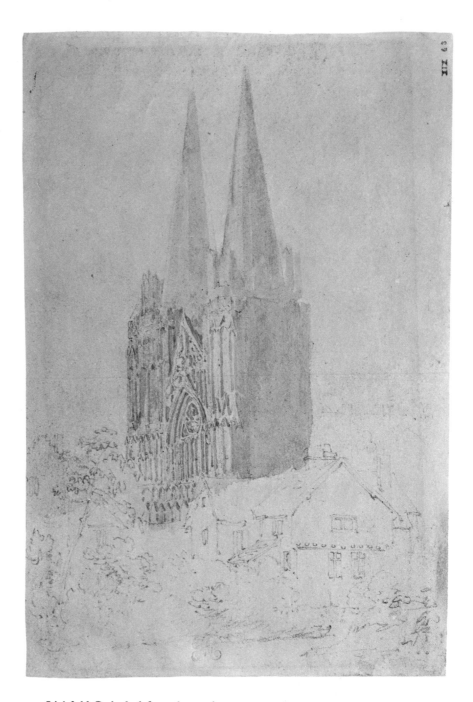

43 Lichfield Cathedral from the south-west

29a

I think Turner intended the book called Matlock for arch-
itecture and the one now called Marford Mill for figure studies.
Figures are quite absent from the first, but in the second are
some very rough sketches from life of some players or fair people
with their stands and a (very vague) merry-go-round. But the
mill interested Turner more – it is as if he felt he ought to try
some figures but was seduced by the old building in spite of
himself. This sketch was the basis of a successful watercolour.

There are some other human figures: a nicely coloured
costume study and a sketch of the head of a woman, almost
certainly Turner's mother, nodding by the fireside – or so it
seems, from the relaxed, intimate quality of the drawing (p 16).

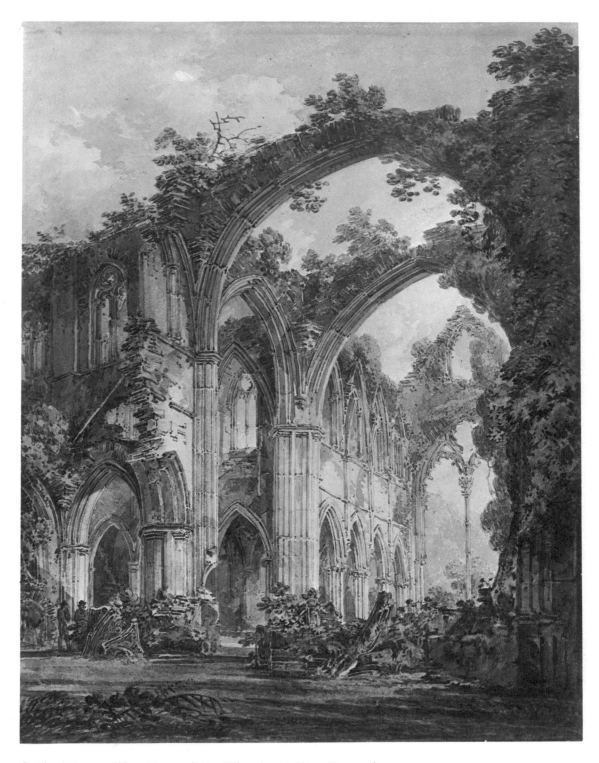

Inside of Tintern Abbey, Monmouthshire (Victoria and Albert Museum)

The well-known watercolour of Tintern Abbey was exhibited in 1794 and must have been done while Turner was not yet 19, before the Matlock and Marford Mill sketches. In its pretty way it is all achievement, and is reproduced here as a fine example of Turner's earliest picturesque style. The unfinished drawing, opposite, of the Bishop's Palace at St Davids, was based on a light pencil sketch in the 'South Wales' sketchbook of 1795 (XXVI). I think it shows Turner at grips with the real forces of architectural composition, not merely manipulating perspective, chiaroscuro, and decoration.

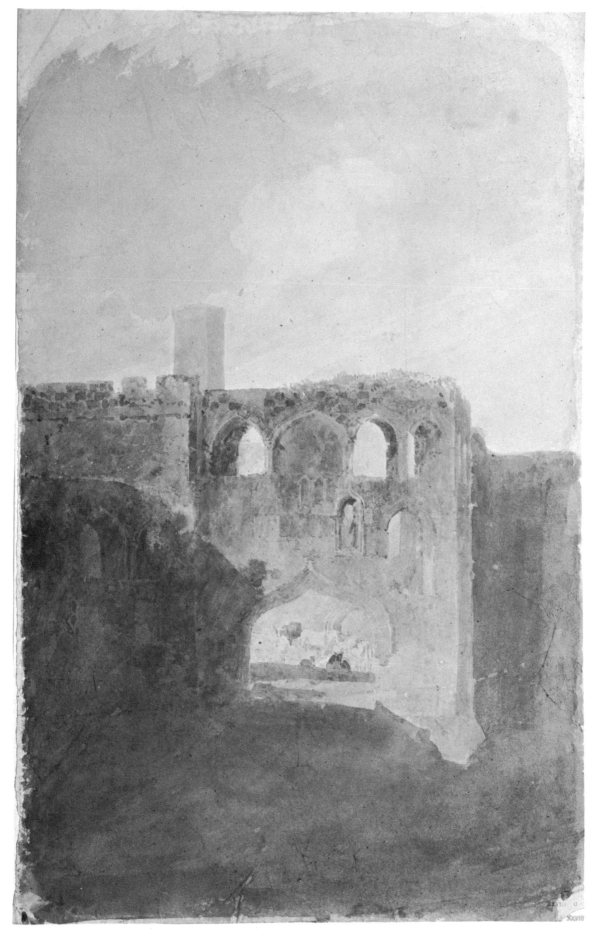

XXVIII-c The Bishop's Palace, St Davids

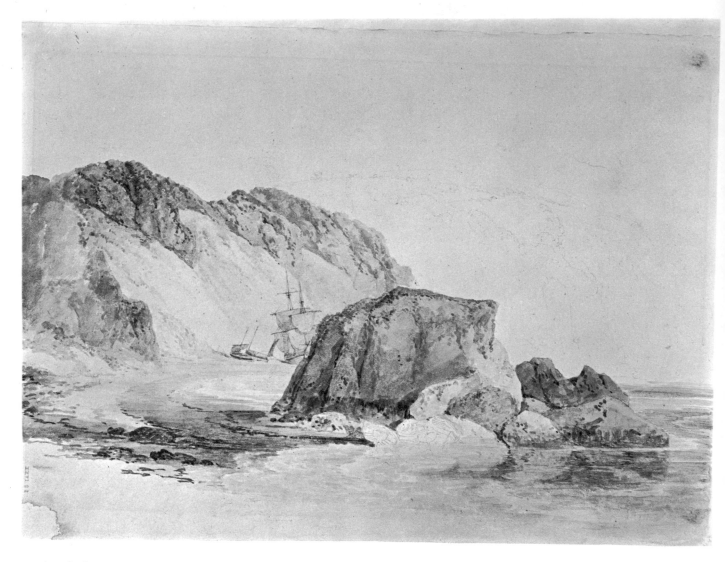

22 A rocky bay

South Wales, 1795

'Of little interest' writes Ruskin damningly on the wrapper of the smaller of these two books. I will let the drawings speak for themselves and for the 20-year-old Turner's broadening awareness of landscape, sea and light. He still has time, too, to make the water-mill look as if it would really work.

The rocky shore of Pembrokeshire is full of mystery and romance as Turner explores it. It is his first experience of the coast: boats, windlasses and crab pots intrigue him, but the sea is only a surface. He has yet to respond to any real experience of it. Gothic buildings fill most of the pages of these books, but he stops to draw mills and kilns by the way. 'More and more', says Jack Lindsay, 'he turned to the world of man's labour, especially when connected with the sea . . .' But men at work are absent or

distant in these scenes, and Mr Lindsay is probably nearer the point when he adds that an interest in such sites 'was encouraged by the picturesque aesthetic – though more widely, the taste for workplaces can be traced back through Paul Sandby to the Dutch painters of the seventeenth century'. I think it would be true to say that almost any incident in the, then, predominantly pastoral landscape interested the young Turner, not specifically people or their work. Here the square-rigged ship, drying sails, and the rowing boats casually beached in the foreground are part of the romantic character of the shore, not the tools of men's daily work.

In the beautiful drawing of the crypt at Canterbury, done 40 years before his famous Petworth interiors (and 150 before John Piper's church interiors), Turner copes ably with the difficulties of vaults and carved stonework, using direct and reflected light, not just for effect, but to help the modelling. This drawing is clearly much more competent than the rocky bay, opposite – it

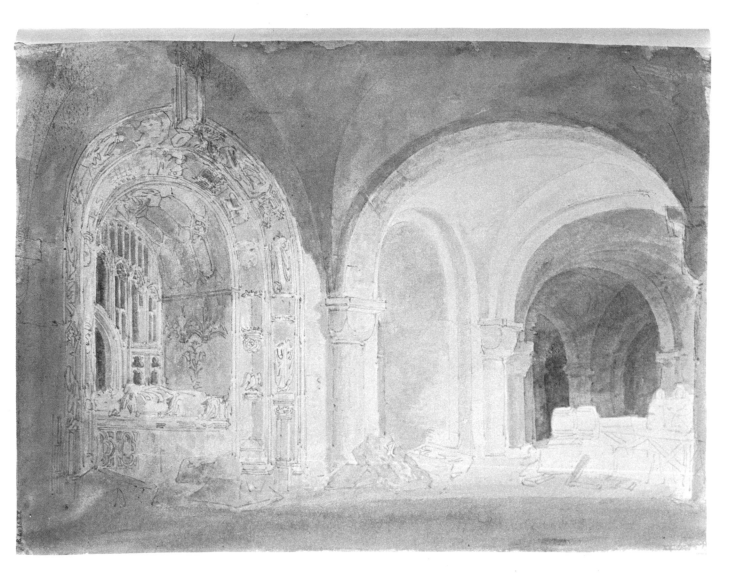

72 Cardinal Morton's tomb, Canterbury

belongs to the 1798 style of 'Hereford Court' (see pages 63–65) though not to the sketchbook of that name – it's the wrong size. Turner did visit Kent in 1798, in April – a visit recorded with much irrelevant detail by an 'intimate acquaintance' who is at pains to tell us how mean and how ungodly Turner was but can give no information about his work at that time (see Finberg's *Life*, p. 46). The endpapers and the first two pages of this book contain some directions, an itinerary, not in Turner's hand, though with some notes by Turner; for example: 'To St. David's and back, 36 miles' – to which Turner has added pathetically, *No inn*.

The crypt on this page and the mountain scene on page 65 are obviously closely connected in their broad colour washes and well-stated but suppressed detail. But I have not attempted to rearrange them – the Hereford Court book is itself a mixture of styles. Turner's Welsh journeys were several and his sketchbooks went to and fro with him.

26 *Carew Castle Mill*

17 *Milford Haven*

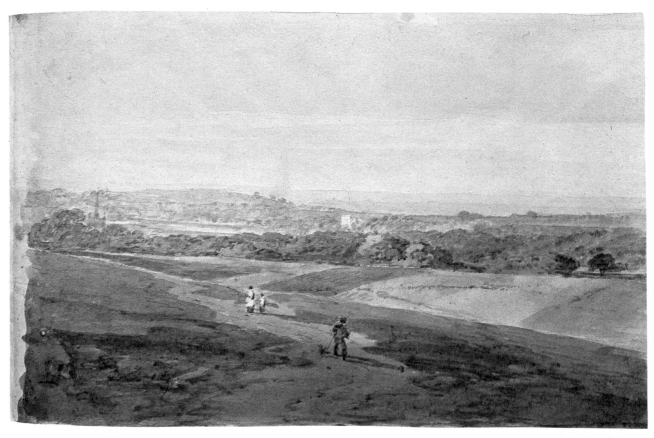

28 A common and open fields

30 Valley and hills

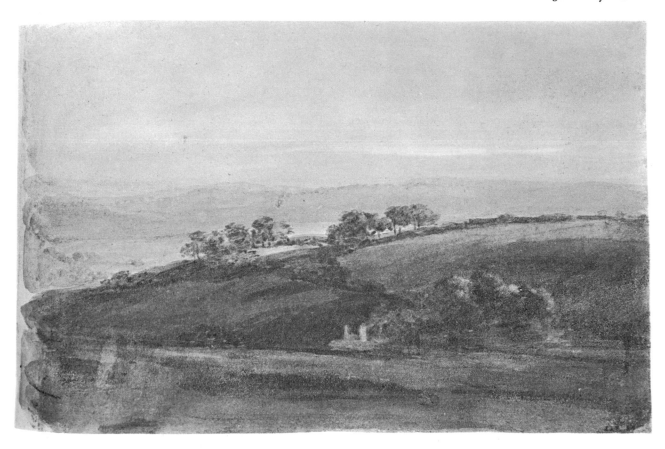

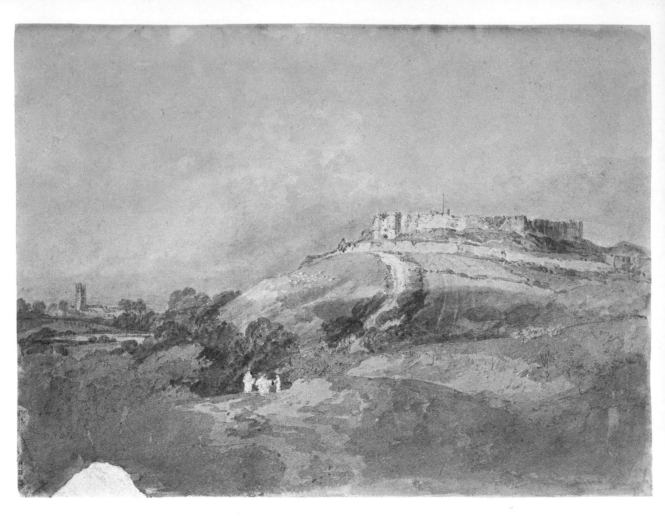

25 Carisbrooke Castle

39 Freshwater Bay

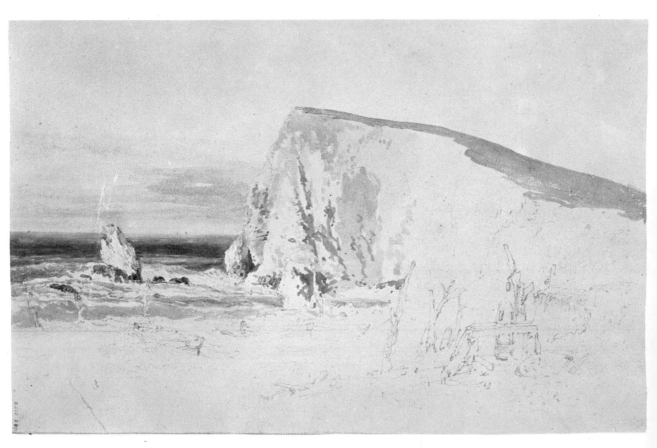

27 Chale Church

The Isle of Wight

Finberg reasons that Turner's visit to the Isle of Wight was at the end of the summer of 1795, in his twentieth year. There is a fussy watercolour of Shanklin Chine by Loutherbourg dated 1794 which may suggest the reason for Turner's visit – Loutherbourg makes the chines look rather grander than they are. Even Turner's painting of fishermen off the Needles was anticipated by Loutherbourg in the insipid little drawing reproduced here. The Swiss artist, who came to England as a theatrical scene-painter, had great prestige – he quickly became an R.A. – and I wonder if Turner went to the Island in a spirit of humble emulation or in a not-too-vain attempt to out-do Loutherbourg. Perhaps it was a mixture of the two motives, for Turner is not like himself in the heavily modelled and grandiose gate of Carisbrooke Castle (folio 25a). It is difficult to avoid the sug-gestion of theatrical scenery here but I cannot prove that this was Loutherbourg's influence. I just feel his presence.

In the distant view of Carisbrooke Castle Turner is very much himself, unaffectedly in love with a bit of landscape and confidently manipulating clouds and their shadows on the fields. This is a fine miniature, thoroughly worked out and not laboured in detail, even though it seems to include every sheep on the hillside.

On the shore he is a little less confident, though I imagine he didn't give up the drawing of Freshwater Bay out of boredom or despair – more likely he intended to complete it later.

The lonely little church at Chale (folio 27) shows how, even when he was preoccupied with pencil details (*Weeds and Briars* notes Turner in the foreground), mood and imagination could creep in. This fluent sketch had not a minute too many spent on it, nor is there a wasted line – it is a minor work of art, not just a pencil note.

11 Winchester Cathedral

In earlier sketchbooks Turner has sometimes seemed to be carried away by his skill in delineating the intricacies of Gothic carving. He is now able to balance his interest in detail by an equal interest in picture making.

The drawing of Winchester Cathedral (folio 11) certainly gives every appearance of accuracy – even as far as the recognisable birch tree – yet the composition is well organised and the two simple colours, grey and ochre, are used to separate the main masses, unify the detail, and at the same time produce a beautiful warm light.

In folio 49, *Nunwell and Brading from Bembridge Mill*, the modelling is perhaps laboured, as it is in the Gate of Carisbrooke Castle, but again we see the sensitive, interested draughtsman at work in the entirely convincing mechanism of the mill and the picture-maker in the handling of the distant landscape and sky.

It is no use always looking at Turner's early work in the reflected light of his great mature works. You have to share his enormous interest in everything he saw in his early travels in Britain. This is not Turner the genius, or even the budding genius: it is young Turner, the best of our topographical artists. And even at twenty he was much better than his teachers.

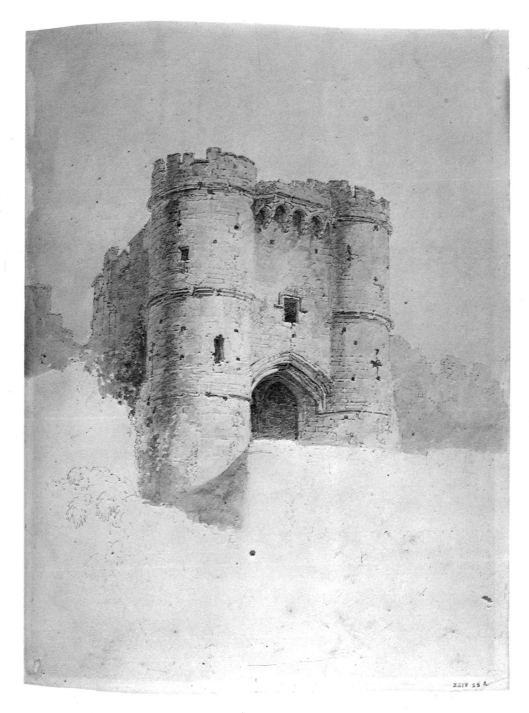

25a Gate of Carisbrooke Castle

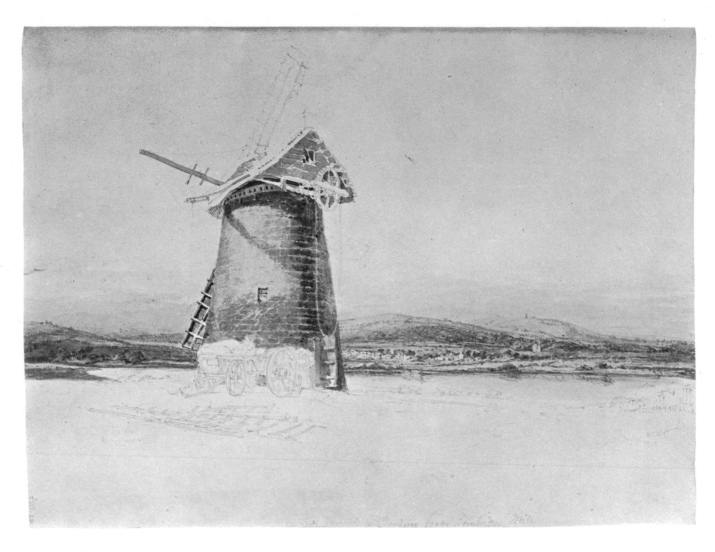

49 Nunwell and Brading from Bembridge Mill

Part of Turner's activities in the Isle of Wight must have been some fishing at night. His enthusiasm for fishing could perhaps date from this time. The picture, his first exhibited oil painting, may be combined from various elements – the fishing boat perhaps from Wales, the Needles from a pencil note in his sketchbook, the combination of the two perhaps from Loutherbourg, the moonlight and lamplight from Joseph Wright – perhaps, but to carry it all through I believe there must have been a first-hand visual experience. It is still possible that Turner chose a nocturnal subject purposely to simplify the unfamiliar problems of composition in a large oil painting. The handling is remarkable, particularly in the representation of water – compare the flaccid sea on page 30. This 'Cholmeley Sea Piece' was followed the next year by another moonlight picture (*Millbank*) and the year after by the pictures of Coniston Fells and Buttermere. In all these Turner seems to have found himself very much at home in scumbling light paint against dark backgrounds. Rothenstein and Butlin describe the texture of *Fishermen at Sea* as 'rather leathery', but Turner's first oil painting was as complete an achievement in its way as the Tintern Abbey drawing of two years before and I make no apology for reproducing it here amongst the sketchbooks.

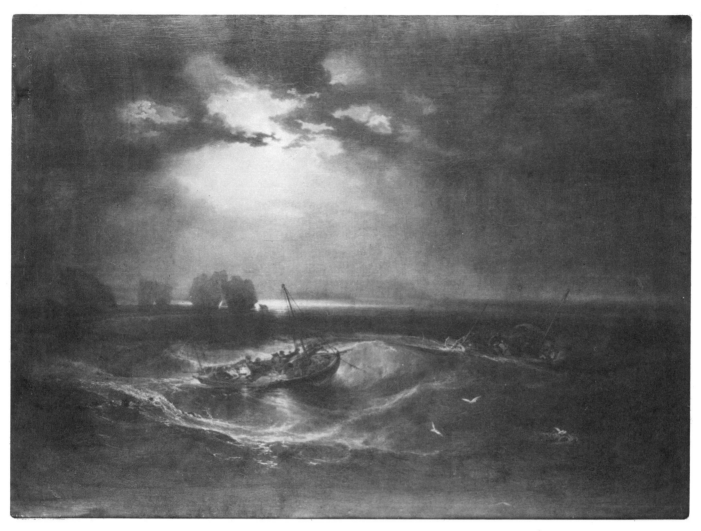

Fishermen at sea, 1796, oil. 36 × 48 ins, 91·4 × 122 cm (Tate Gallery)

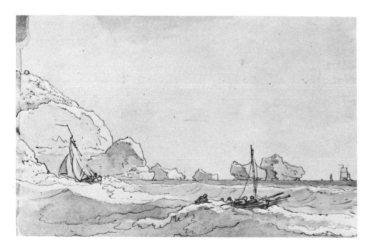

Loutherbourg: Fishing boats by the Needles

1796: *Studies near Brighton (overleaf)*

Finberg notes with some distress the apparently small amount of work done by Turner in this summer, suggesting that the 31 pages completed out of 96 in this study book (XXX) are the work of an invalid who had gone to Brighton to recover. He rejects the theory of the previous biographer, Thornton, that the young artist was in love, and unhappily. Turner may well have been both ill and in love but we have no proof at all of either. Surely it is obvious that this little book of coloured paper is the pair of the 'Wilson' book (XXXVII, p.52) with its grey-brown leaves, and that what Turner was doing with his free time during 1796 and 1797 was collecting subjects for paintings.

The Wilson book was provisionally dated 1797 by Finberg and I do not feel there is anything to be gained by altering its position here. It was clearly in Turner's pocket for more than one summer. If these studies near Brighton can be dated 1796, so be it. In this year and the next, obviously, Turner had oil painting very much on his mind. His use of body colour on tinted paper in both books more than hints at his intentions.

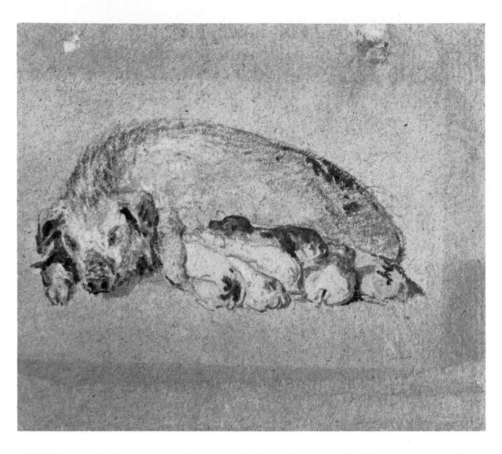

93 Pigs

92 Unloading a boat

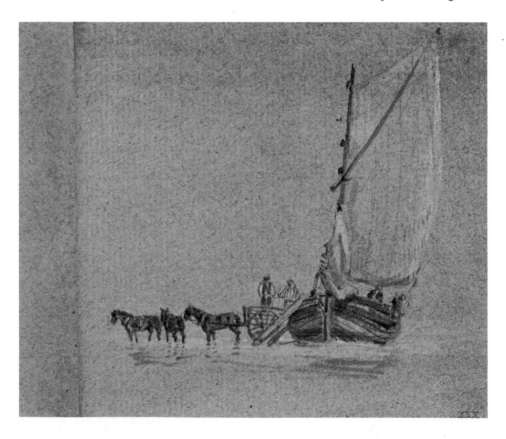

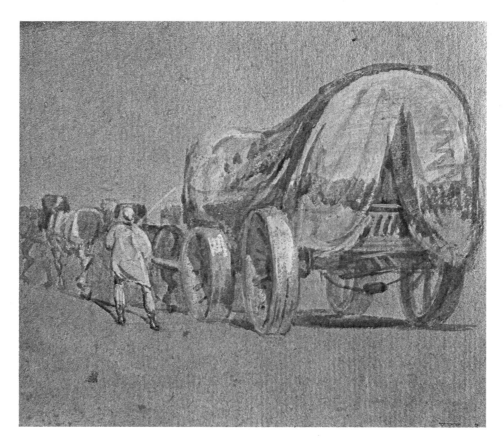

3 Waggon with team and waggoner

52a Side view of a sailing boat

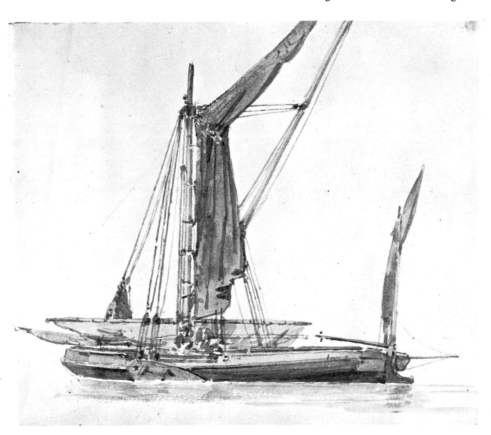

The North-east

In 1797 Turner had a number of commissioned drawings to do
in the North. He worked his way from Derbyshire through
Sheffield, Doncaster, Wakefield, Leeds – Kirkstall Abbey –
Durham, to Tynemouth, Norham and Melrose. He was mostly
collecting castles and abbeys. His business done he crossed to
the Lake District in search of poetic landscape. He had also
some drawings to do in Ambleside, at Harewood, and in York.
He took two sketchbooks, the first a largish quarto, about the
same size as the book you are reading and the second, called
'Tweed and Lakes', a workmanlike $14\frac{1}{2} \times 10\frac{1}{2}$ – the largest so
far. He may also have taken the much smaller Helmsley
sketchbook (LIII).

80 Louth, Lincolnshire

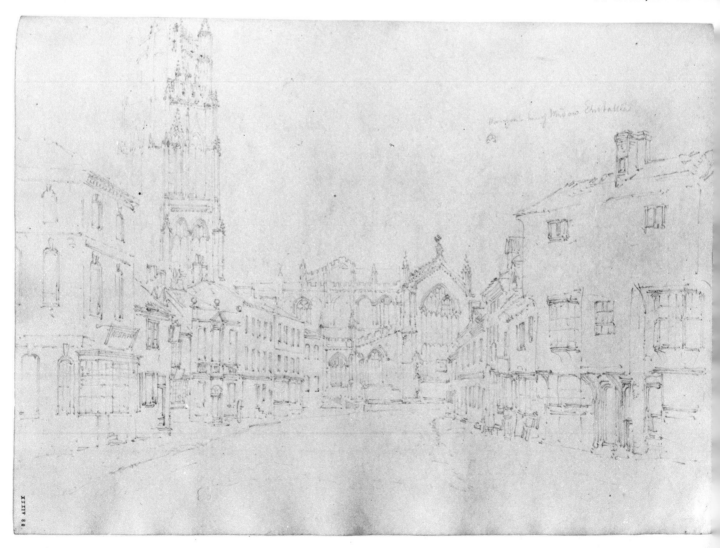

56a Berwick-on-Tweed, early morning

The North-east seems to have inspired Turner. Dunstan-
borough and Norham castles were the subjects of watercolours
exhibited the following year, and with quotations from Thomson
attached we know they were not mere topography. Though his
purpose here is to make pencil records of old buildings, Turner
frequently feels lyrical and resorts to pale, luminous washes of
colour. The small boat setting out at sunrise, Berwick-on-
Tweed, contains all the elements of the 'real' Turner – even the
lines of the composition, pivoted on not-quite-central axes; a
plan which served him many times after. The light, too, though
diffused, has its source within the picture area – where he liked
it best.

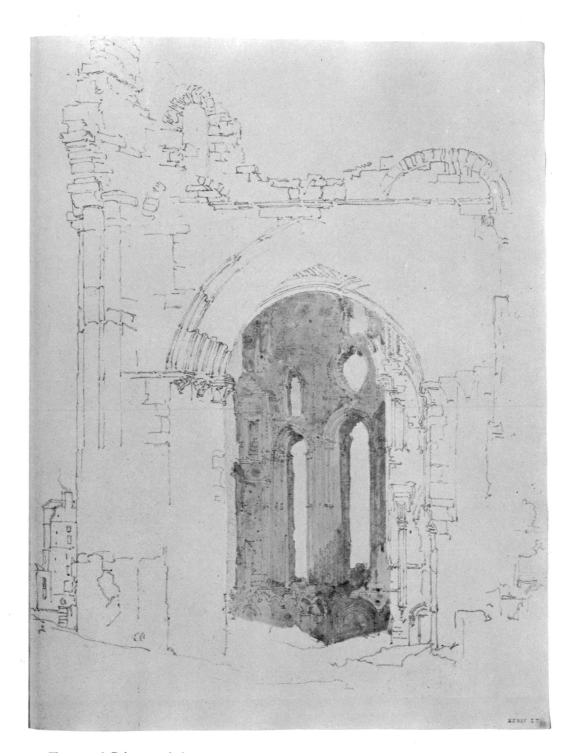

33 Tynemouth Priory, a window

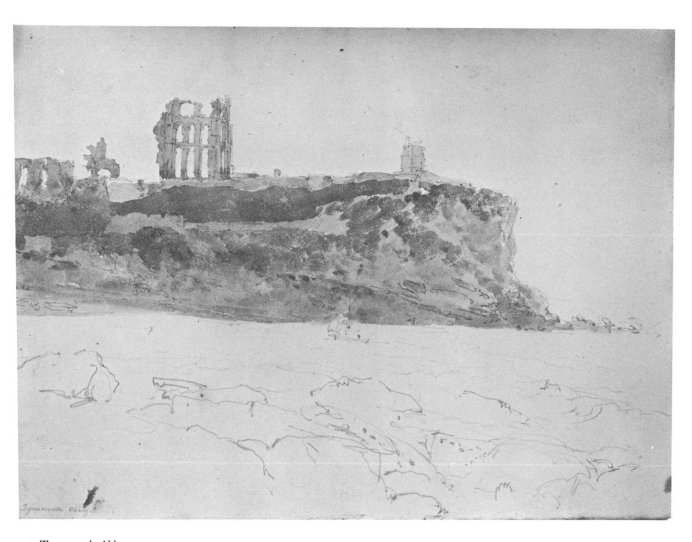

35 Tynemouth Abbey

Amongst the unmounted drawings in the Turner Bequest is a
study of Tynemouth Abbey with rough water and boats done
in a vigorously brushed body colour, which shows that painting
was not far from his thoughts. But the quieter view across the
river is a more promising design (folio 35).

The unfinished drawing inside the ruins shows Turner in his
best topographical manner: detail well related to structure,
perspective in almost complete control, colours unobtrusive.
Lacking a horizon for the cliff-top ruin, he adds to the left a
glimpse of every-day architecture, cunningly continuing the
perspective of the windowed wall. A smoking chimney adds
realism to the contrivance.

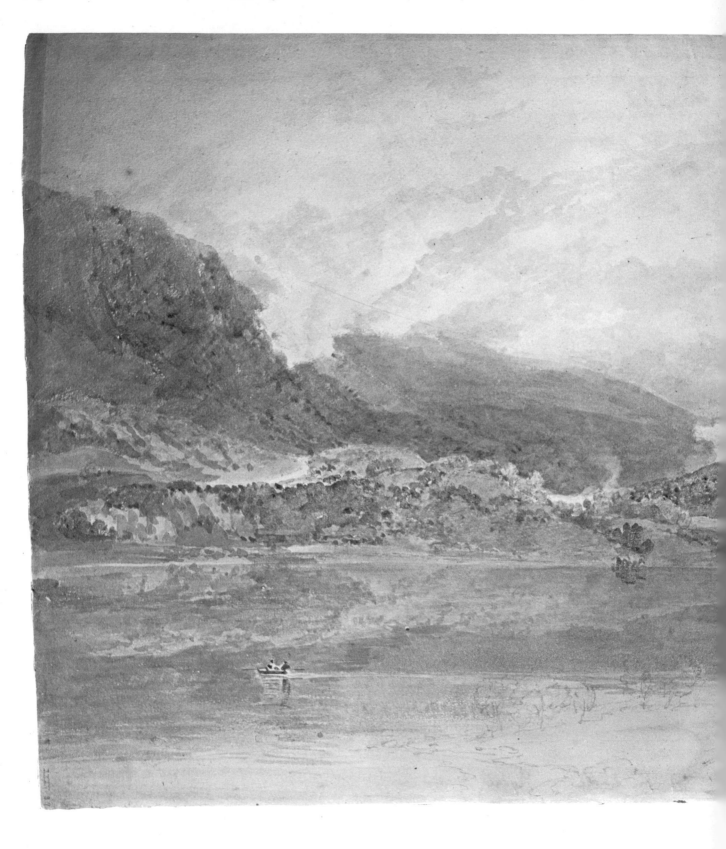

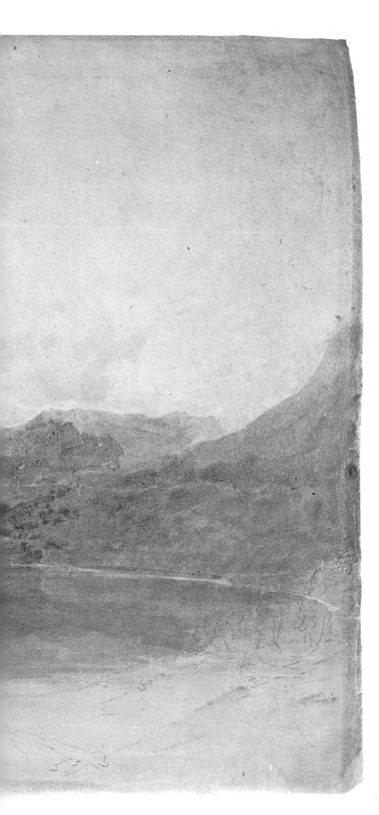

The Lakes

Turner is now an oil painter with all the seriousness of purpose that this implied. It is no surprise to find him in the Wordsworth country – Wordsworth and Coleridge were not the first to discover the poetic nature of Lakeland scenery – and not surprising either, to find him using his sketching materials in a more plastic way. I wish he had used his oil paint with half the freedom and lightness of this lovely drawing of Grasmere. Scale and depth are far better represented on the paper than they are on the dark canvas of the Buttermere painting (p 49). We can manage without the foreground detail that is only pencilled in, and the fact that Turner used his finger rather than a brush to dab in the trees in the middle distance does nothing to detract from our appreciation – though it might have done to a contemporary.

The composition is not quite felicitous, of course: the swirling clouds and the wisp of smoke are trying to form themselves into a Turnerian vortex, at variance with the calm beauty of the water below, and the clouds break rather abruptly the slopes of Rydal Fell and Raven Crag (left and centre). All the same I feel privileged to have a hand in reproducing this and the Buttermere drawing for the first time.

The Grasmere drawing on this page seems to be another attempt at the theme worked out more successfully in 'Buttermere' – part of a second lake, in this case Rydal water, a few feet higher, is visible beyond the foreground water.

87 Grasmere Lake, Rydal Water

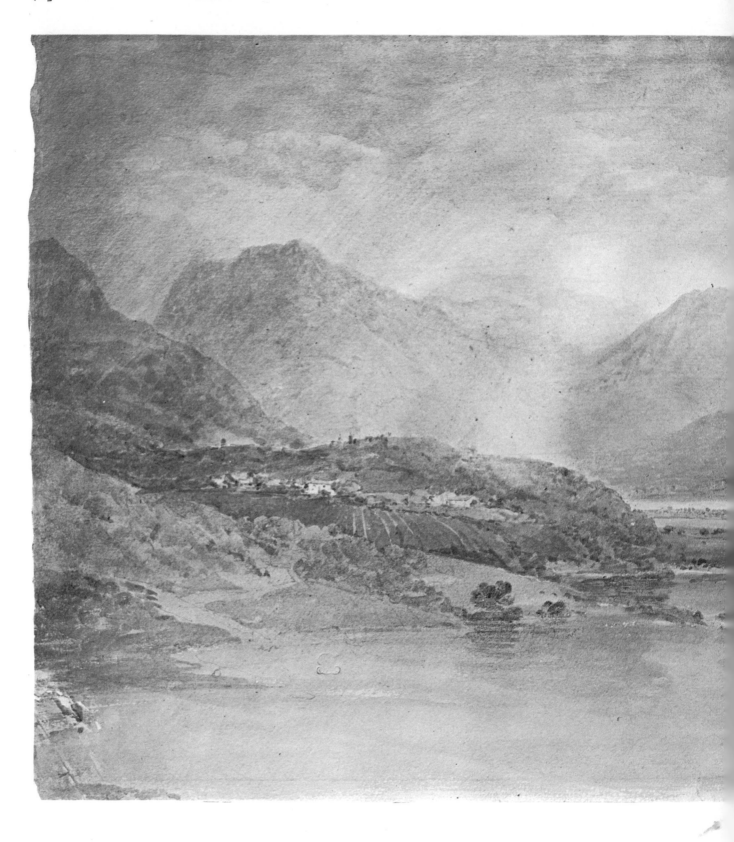

The Buttermere sketch appeals to me far more than the painting, which in modern terms is like the Film-of-the-Book. Also, the painting is gloomy: how much it has darkened I don't know – the sketch has faded a little. Perhaps the great charm of the drawing, besides its noble qualities of scale and composition, is its freshness – all this fine scenery was new to Turner. Despite a deplorable lack of green in the colouring, its poetry is still intact, Thomson or no. The verse, and the rainbow, were attached later to the oil painting, which was exhibited at the Academy in 1798 and is now in the Tate.

Buttermere Lake with part of Cromackwater, Cumberland, a shower

'Till in the western sky the downward sun
Looks out effulgent – the rapid radiance instantaneous strikes
The illumin'd mountains – in a yellow mist
Bestriding earth – the grand ethereal bow
Shoots up immense, and every hue unfolds.
vide Thompson's *Seasons*

Turner might well say *vide*, for he did less than justice to the poet by leaving out several inconvenient lines from the middle of the quotation and mis-spelling his name. 'Effulgent' is a word, I feel, more descriptive of the poet than of his, and Turner's, subject matter. The attempt to cast the direct inspiration of nature into the mould of eighteenth-century drawing-room art was bound to fail, and Turner is still far from creating the taste for which he could work expressively in oils.

84 Buttermere Lake

72 *Ouse Bridge*, York

Turner did not neglect his topographical work while his head
was full of quotations from Thomson. The large format of the
book and Turner's obvious desire to seek original viewpoints
give his drawings at Lancaster and York (the old Ouse Bridge,
above) a new expressiveness. He is now able to leave things out
and make his line work harder to express mass and space. In
some interiors of York Minster in this book there is still some
impressively intricate Gothic detail.

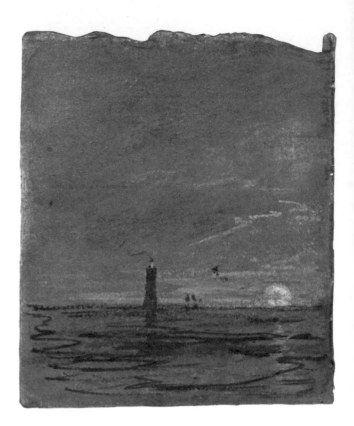

8 Sunset with lighthouse

1 Looking out to sea

The 'Wilson' sketchbook

This tiny book, $4\frac{1}{2} \times 3\frac{5}{8}$ inches, contains 128 pages of grey paper
prepared with a brown wash. The label on the binding says,
in Turner's writing: *Studies for pictures – copies of Wilson.*

The copies of Wilson are in the minority. The book is filled
with a profusion of colour studies, mostly finished, some very
detailed, others with a new economy of brushwork. The whole
thing is fascinating, rich and various. It is a three-dimensional
masterpiece and a muddle, a collage, of all that deeply interested
Turner for a year or more of his life. The material cannot all
belong to the year of the 'Tweed and Lakes' and the North-
eastern book – obviously it must go back to 1796 and fill the
hiatus which so worried Turner's biographers. There is no point
in writing more and using space which can be used to reproduce
one more page. I have tried to make a fair selection, including
some copies and some of the *genre* subjects which Turner did not
exploit until some years later.

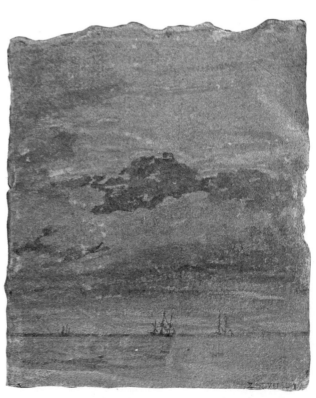

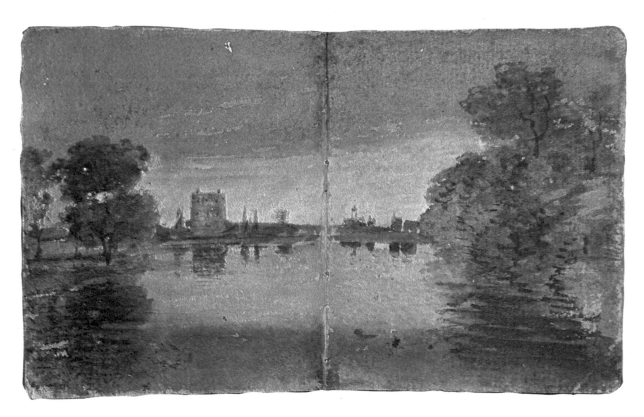

22, 23 River scene

36, 37 Interior of a church

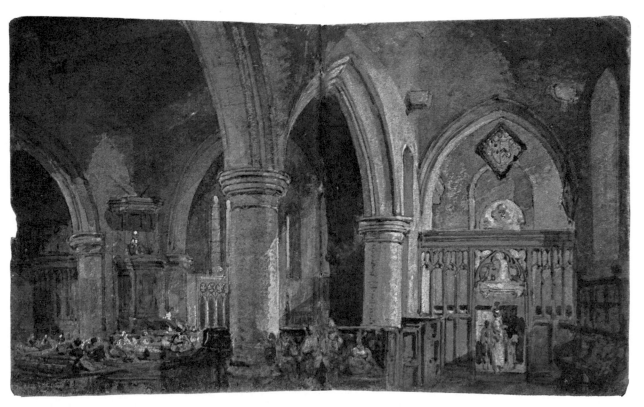

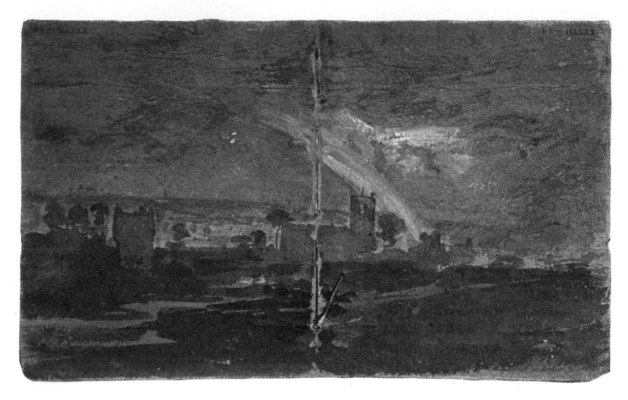

48, 49 A village, with a rainbow

40, 41 Copy of a picture?

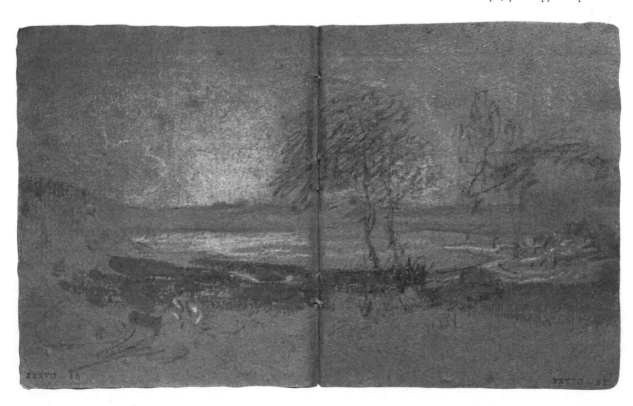

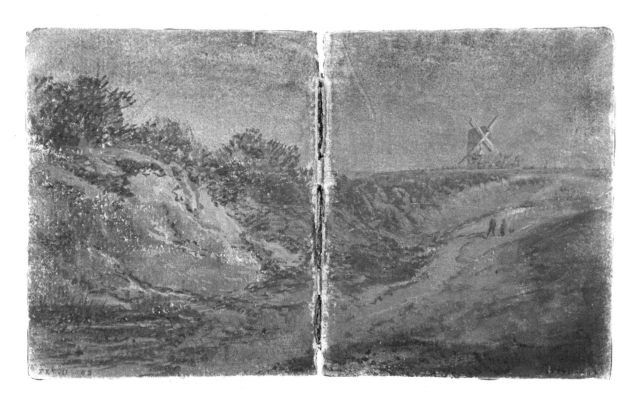

62, 63 Pathway across a common

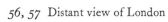

56, 57 Distant view of London

82, 83 Ramsgate?

94, 95 Tower by the sea

106, 107 Sailing boats

110, 111 Fishing boats

80, 81 River scene with boats

66, 67 Boat on a calm sea

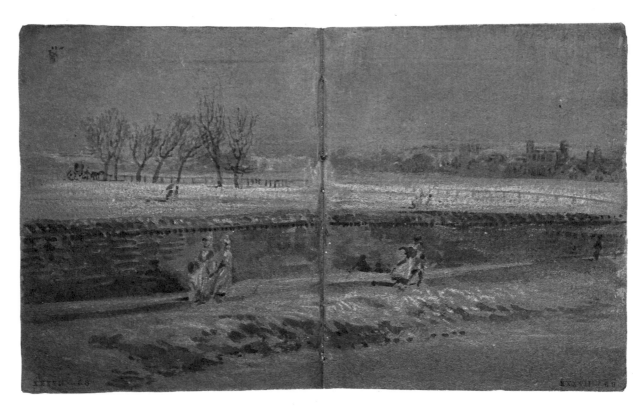

68, 69 Snow scene (Lewisham?)

74, 75 Landscape with dark clouds

4, 5 A study

2, 3 Dark cloud

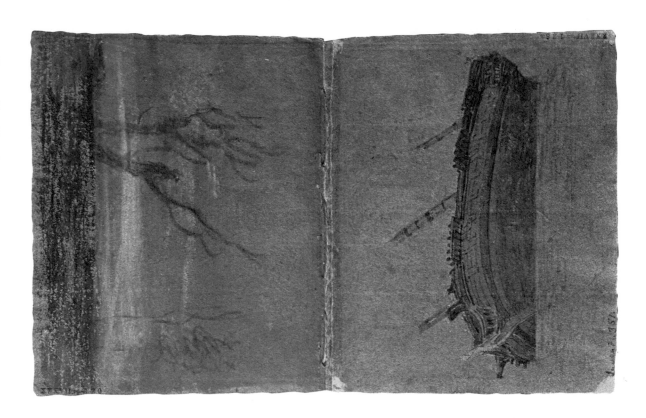

120 Trees, with yellow sky

128 Study or copy of a dismasted ship

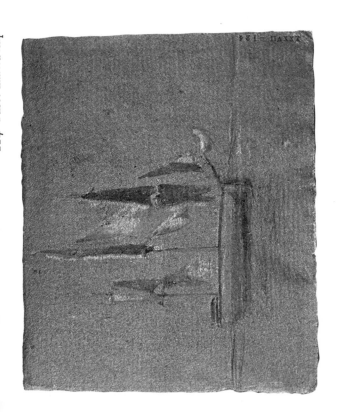

114 Sunset or sunrise, at sea

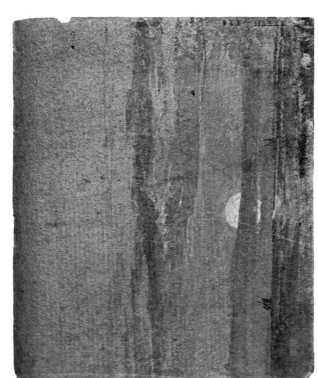

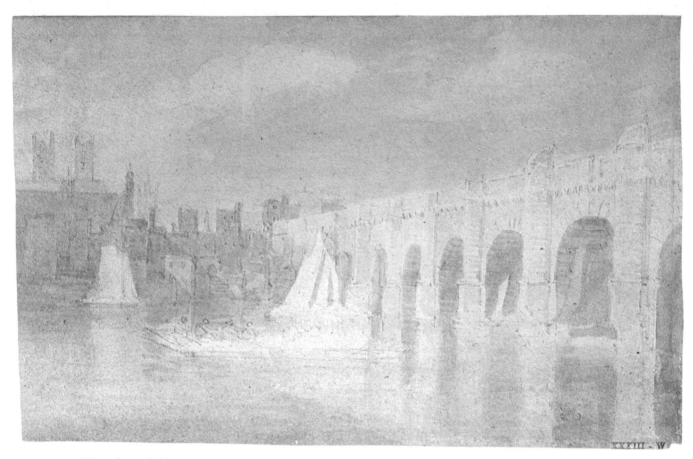

xxxiii-w Westminster Bridge

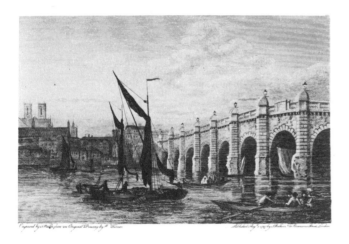

engraving from the *Itinerant and Copper Plate Magazine*, 1797

Working drawings

The beautiful watercolour of old Westminster Bridge – this is Westminster before the Houses of Parliament were burnt down – is not from a sketchbook so far as I know. The paper is quite thick anyway, and Turner had only a mile and a half to walk from his Maiden Lane studio, so he had no need to take a book. He may have worked from a boat. What the engraver made of it is shown beneath. It can hardly have given any satisfaction to its originator.

When Turner engraved his own work, in *Liber Studiorum*, his preoccupation with classical composition led him into a different sort of faithlessness to his originals. It seems that re-interpretations in the visual arts are always damned from the start. The etching dates from 1811. Various states of the mezzotint are preserved, all proofed in the *Liber's* plushy brown, much at variance with the airy hues of the unfinished sketch of thirteen years before in this 'Hereford Court' sketchbook.

'Hereford Court' was Turner's abbreviation of Hampton Court, Hereford, where he did some commissioned drawings in 1795. Some of the work in this sketchbook obviously dates from that year. There is a great mixture of styles here, the connecting feature in the coloured drawings being the unusual weight of

81 Junction of the Severn and the Wye

from the *Liber Studiorum*

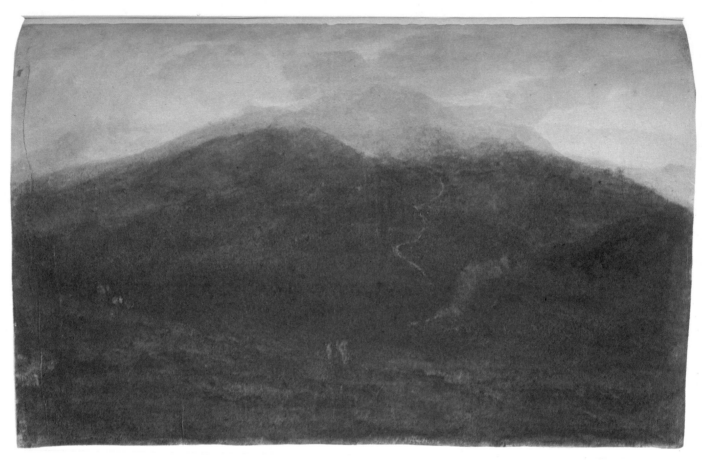

83 Path up a mountain

70 *Pool on the Summit of Cader Idris*

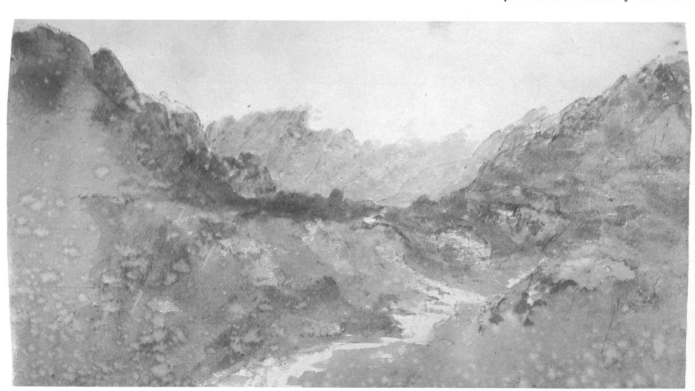

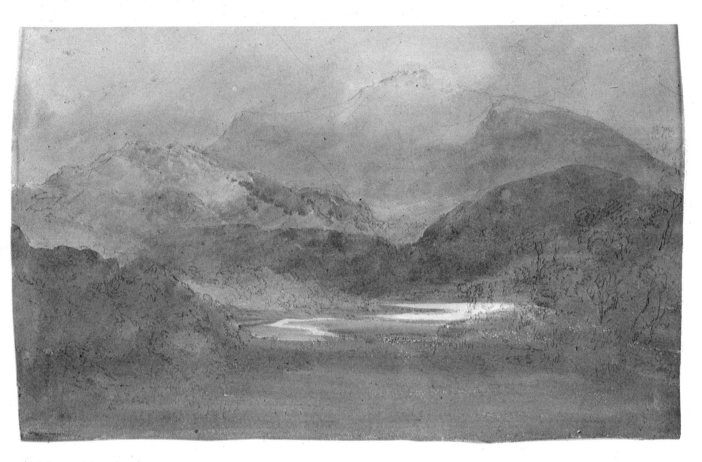

98 River, with mountains

colour – watercolour used in an untypically solid way. Most of these heavily worked sketches are so dull and so prosaic in conception as to suggest the alien hand of some inept pupil. Even so Turner certainly worked hard in Wales to produce some workable ideas for painting – and usually failed. He looked to the mountains to provide powerful subjects, but except for a couple of castles, nothing much of gallery proportions came of his work there – though there are many notes of commissions to be executed amongst these pages, and a number of watercolours were based on the sketches.

It is this book, not the little book of studies shown in the preceding pages, which should be called 'studies from Wilson'. It was Wilson, surely, that led Turner to the pool on Cader Idris – his blocked-in sepia beginnings are ruined by large raindrops, however, leaving us with an unintentionally decorative proof of his working methods.

The range of subjects is wide: beginning at Malmesbury and Tintern, and the junction of the Wye and Severn, then Brecon, Carreg Cennen, Kilgarren, Pont Newydd near Ffestiniog, Harlech, Snowdon from Capel Curig, Dolbadarn, Bettys-y-Coed, Conway, Castell Dinas Bran, Llangollen, Cader Idris, Beddgelert Church by moonlight, and the first two of Turner's many drawings of Caernarvon Castle. It sounds like a wonderful picture book of Wales, but this the Hereford Court book is not – it's a working-out book.

One of the ideas Turner was trying to work out was concerned with a climbing theme. Groping for this idea is a snatch of his verse following the pieces quoted on page 97, from the 'Swans' sketchbook – begun in this year, 1798:

Oh how weakly then the way worn traveller
Threads the mazes towards the Mountain top.

The drawing on folio 83 is obviously not a piece of pure landscape: this dark mountain with its gleaming path is a symbolic, not a chorographic hill. The zigzag path reminds us how often Turner's compositions, made up of largely inanimate masses, have near their centres some small but significant movement – it may be as literal as the rowing boat in 'Buttermere', or (much later) the subtly accented railway engine in *Rain, Steam and Speed*: or as obvious as any piece of 'action' – the foreground figures of all the classical landscapes: or only hinted in a wisp of rising smoke or the curve of a bridge. These isolated movements are always clearly definable, measurable shifts in time against the still, central point of the composition. They are part of Turner's completely original attitude to time and place, and anyone who is not quite sure why Turner's pictures fascinate him would do well to look for these small mechanisms. The sea pictures, of course, are often all movement, but here the process is reversed: the centres of violence serve to point to the much larger, slower movements of sky and horizon. Always, Turner's portrayal of movement is controlled and proportionate to the structure of his composition –

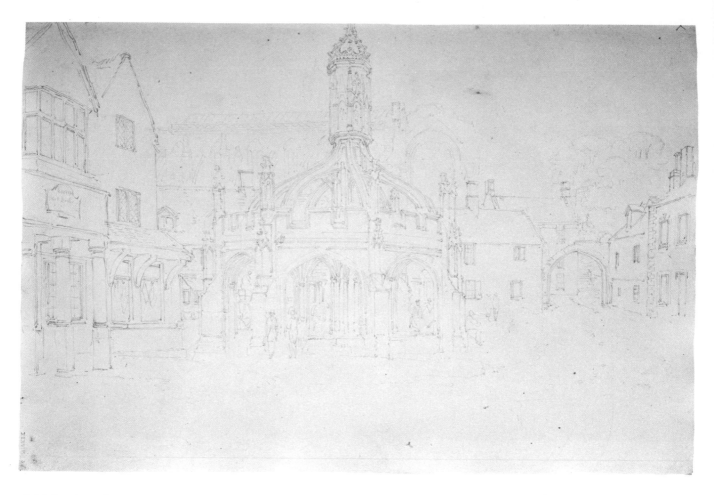

6 Malmesbury Cross

even his suns set always exactly in the right place, so that one could work out their previous arcs, if one wished, on the surface of the picture.

All this is in no way similar to the frozen movement of the photographer's art – that came later – nor is it incidental, like Constable's *Leaping Horse* (which seems to move less than any other part of the picture) or like the implied but unreal activity of the small human figures in almost any landscape before 1800. Only Poussin before the nineteenth century had built a mechanical sort of movement into his compositions – that is, the movement of one part against another, not the 'sense of movement' which is an integral part of all good draughtsmanship. Perhaps the most remarkable instance of Turner's dynamic sense is the devastating black vertical of the great *Burial at Sea* of 1842.

This takes us rather a long way from the stumbling, upward climb of 1798, but we may learn something about the beginnings from knowing the end: one theme of Turner's life – the 'Fallacies of Hope' – has its hopeful beginning here in Wales.

Two references to Turner's tour in Wales occur in Farington's *Diary* and are quoted by Finberg. Wednesday, September 26, 1798: 'William Turner called on me. He has been to South and North Wales this Summer – alone and on horseback – out 7 weeks. Much rain but better effects – one clear day and Snowdon appeared green and unpicturesque to the top.' October 24: 'Hoppner, he told me, had remarked to him that

his pictures tended too much *to the brown* and that in consequence of that observation he had been attending to nature to enable him to correct it.' I think he did try – it is unfortunate that he seems to have mixed his warm greens with indigo, which has faded, leaving a foxed ochre, and his cool greens with gamboge which has also disappeared – this is a theory, anyway, which may account for the almost complete absence of green from the sketchbooks of this decade. I say almost, for there is one beautifully green drawing; significantly enough not a watercolour but a pastel (p 143). Ruskin remarked on Turner's 'aversion to bright green' (Lindsay, p 258), and of course he was no more than fashionable in this for it was not until the middle of the next decade that he, and later Constable, 'discovered' that the landscape was green. Perhaps, in the eighteenth century, there was too much green – the towns were small and the fields even in winter were not mostly under the plough as ours are. Green may have been dross in a civilised world that valued fine furniture and well-varnished old masters.

The 'river' in folio 98 is the first of many discordant yellows that must be the result of one component of the colour being fugitive. In every case where this happens the drawing has been exhibited, showing the marks of the mount at the edges.

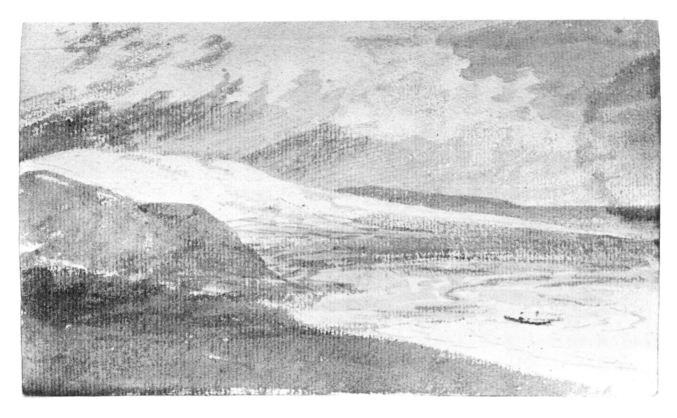

66a Shore with mountains

North Wales

Turner covered a lot of ground in Wales, but he *was* on
horseback. He had started from Mr Narraway's house in Bristol.
According to a Miss Ann Dart, a niece of Narraway's, writing to
Ruskin in 1860, her uncle 'gave him a pony, and lent him a
saddle, bridle and cloak, but these he never returned. My uncle
used to exclaim what an ungrateful little scoundrel, and with
this incident the intercourse between Turner and our family
terminated'. Turner, she said, 'did not make himself other than
pleasant, but cared little about any subject except his drawing'.

The book labelled North Wales is mostly monochrome. It has
some rough pinkish paper bound in, and black and white chalk
are used throughout. Annoyingly, the most effective drawings
are on the white paper and Turner has used white chalk where
it doesn't show up. Folio 66 is in the pink section but here the
paper is covered with monochrome gouache. This is a very
fresh, modern looking drawing, with much 'dry brush' work on
the rough paper.

In the two folios 8 and 9, of waterfalls, Turner has suddenly
been forced to indicate patches of tone in pencil. These patches
of 'shading' are a new departure. The water is indicated by
white chalk, almost invisible on white paper.

Other pencil subjects include Harlech and Criccieth Castles.

There is also a watercolour sketch for an oil painting of *Harlech
Castle, from Twgwyn ferry, summer's evening twilight*. A
quotation from Milton's *Paradise Lost* appeared in the catalogue:
 Now came still evening on, and twilight grey
 Had in her silver livery all things clad.
 . . . Hesperus that led
 The starry host rode brightest till·the moon
 Rising in clouded majesty unveiled her peerless light.

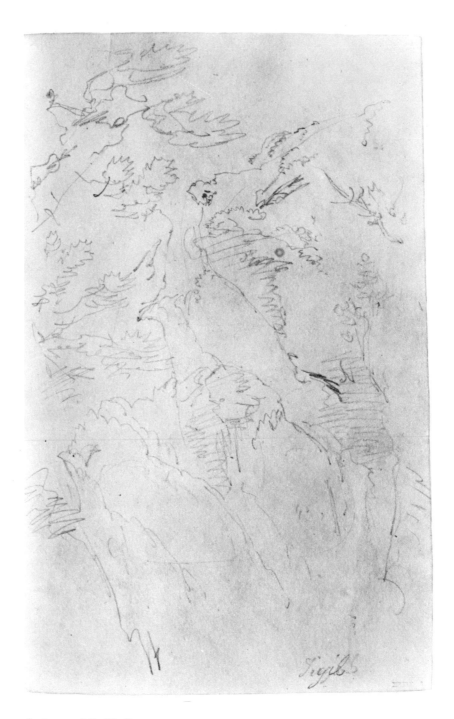

8 A waterfall. *Tigil*

9 Waterfall, probably Cynfael Falls near Ffestiniog (Finberg)

85a, 86 Church and house (Layccok?)

'*Dinevor Castle*'

This little book has an air of intimacy compared with the much larger sketchbooks of the Welsh tour of 1798. It is used for two important compositions, some tentative mountain scenes, and a variety of architectural drawing, some of which has an endearing warmth. There is a particularly pleasant atmosphere in the drawing, titled 'Laycock?' by Finberg, on folios 85a–86. All the drawings except one, the watercolour overleaf, are in pencil, usually using both facing pages. The paper is Turner's usual Whatman with the watermark 1794.

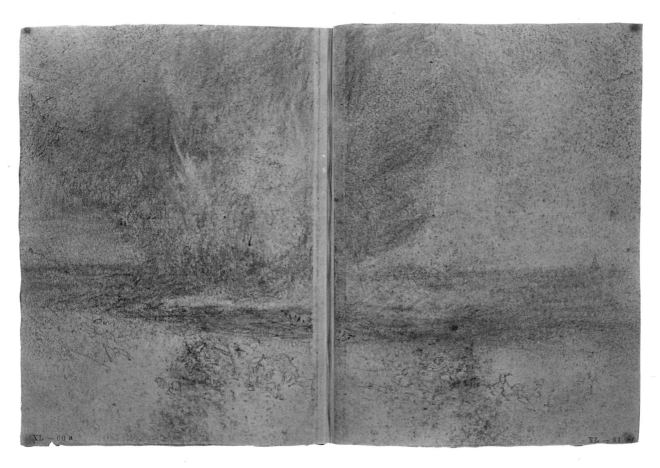

60a Design for *The Army of the Medes destroyed by a whirlwind* (?)

On this page is an unusually ambiguous design which I think must be a sketch for *The Army of the Medes destroyed in the desart by a Whirlwind foretold by Jeremiah Chap. XV, v. 32 and 33*, to give it its full title. The reference should really be to chapter xxv, but even then the title doesn't quite fit the verses:

Thus saith the Lord of hosts, Behold, evil shall go forth from nation to nation, and a great whirlwind shall be raised up from the coasts of the earth.
And the slain of the Lord shall be at that day from one end of the earth even unto the other end of the earth: they shall not be lamented, neither gathered, nor buried; they shall be dying upon the ground.

The picture was exhibited in 1801, but there is no other record of it. If you have an oil painting resembling the sketch in your attic, it may be worth £100,000. At the Exhibition it was received with mixed reactions: West, the president, must have been referring to it when he said '. . . it is what Rembrandt thought of but could not do' – this remark would not have fitted the sea piece which was the only other oil Turner exhibited. The *Star* newspaper said that 'to save trouble the painter seems to have buried his whole army in the sand of the desert with a single flourish of his brush. The *Porcupine*: 'all flags and smoke'.

Of course, Turner may have taken it back and painted over it. But geniuses, it is well known, rarely waste an idea – he would have made a fresh attempt of some sort if he had thought the painting a failure.

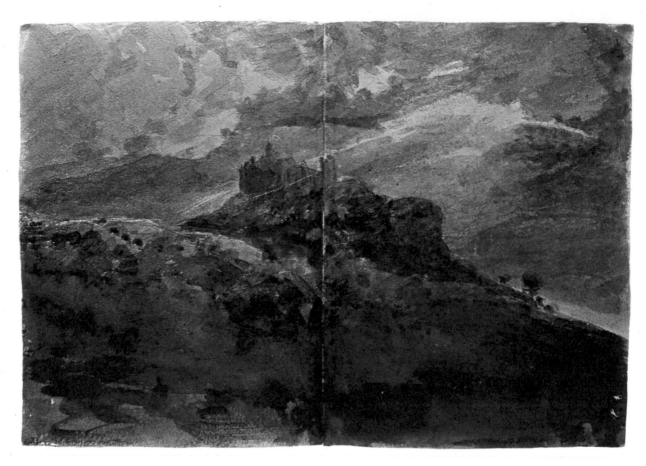

38 A ruined castle (Caer Cennen ?)

The watercolour on folios 37a–38 was tentatively titled
Caer Cennen by Finberg. The general lines and mood resemble
the small early painting in the Tate called *Mountain Scene,
Wales*. The style of the drawing is wild and dramatic, well in
keeping with the monochrome wash drawings in Wales (pages
67 and 87), and the pastel sketches for Dolbadarn (pages
94–95). Some drawings of Malmesbury at the beginning help
to date this sketchbook as 1798, but this does not mean that all
its contents were done in that year. 1800 is more likely for the
'Whirlwind', exhibited in the spring of 1801, since at this time
of his life Turner invariably conceived and executed his oil
paintings within a season.

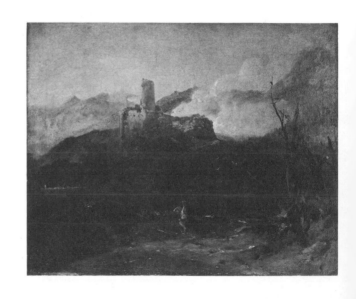

3a A castle

84a, 85 Castle, and *Laycock door, window, stairs*

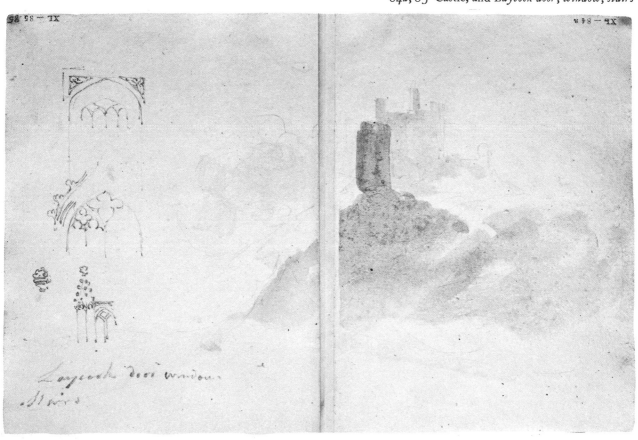

36 Bridge, with mountains

A spectacular case of indigo fading – a drawing from the
Cyfarthfa sketchbook which was on exhibition until 1905, when
someone happened to notice it had turned brown. There seems
to have been a considerable amount of blue all over the drawing.

28 Boats towing men-of-war

Cyfarthfa

Some of Turner's seven weeks in Wales were spent in the south.
He had noted in the 'Hereford Court' book:

*4 drawings of the Iron Works of Rich^d Crawshay Esq^re at
Cyfarthfa, near Merthyr Tidvil, 18 miles from Cardiff – 16 from
Brecon*

10/9½ by 13 inches – 5G. each

2 M^r Blackshaw Carfilly Castle

One of the pencil sketches of the Iron Works is reproduced
overleaf – an industrial landscape of the late eighteenth
century, and an unusually objective and accurate one.

The pencil work for Caerphilly Castle was duly executed on
four pages. There are some other castles and some impressive
drawings using brown and grey wash of shipping in a river
running in a gorge. Finberg says it is probably the River Usk.

These large, serene drawings have a very different mood from
the vigorous mountain landscapes of the rest of this tour. It may
be that Turner, while doing his commissioned work, was
relaxing between-times on the river: ships and boats were
irresistible to him even when he wasn't planning a masterpiece.

76] 1 *Cyfara Works*

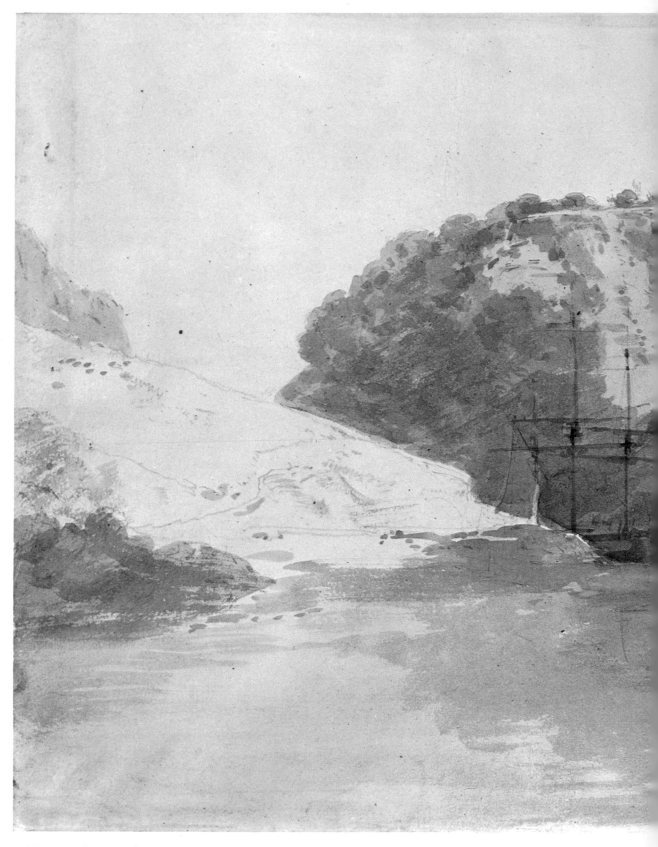

26 Boats towing men-of-war

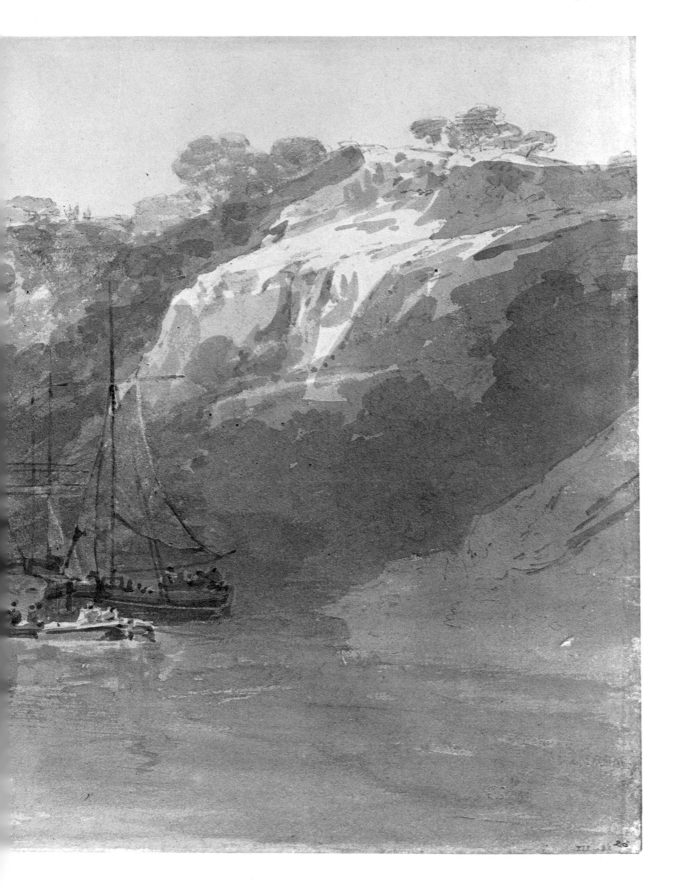

'*Academical*'

The title is Turner's. The blue paper has a brown wash over it. The book begins in the life-room with some carefully modelled male and female figures whose heads fit so badly that I cannot bring myself to reproduce one. I think they must date from Turner's 20th year, his first in the life classes. He worked in watercolour with white – body-colour in effect. There are a few landscapes which could also date from 1795, in Wales. They are heavily worked and immature in every way: these also I have passed over. The chalk torso remains to justify the title – and perhaps belongs to the year 1798.

12 Pencil and white chalk

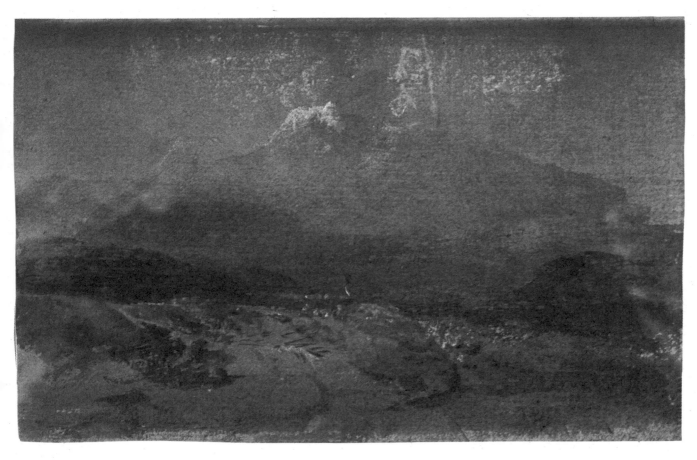

48a A mountain, its head in cloud

45a River with ships

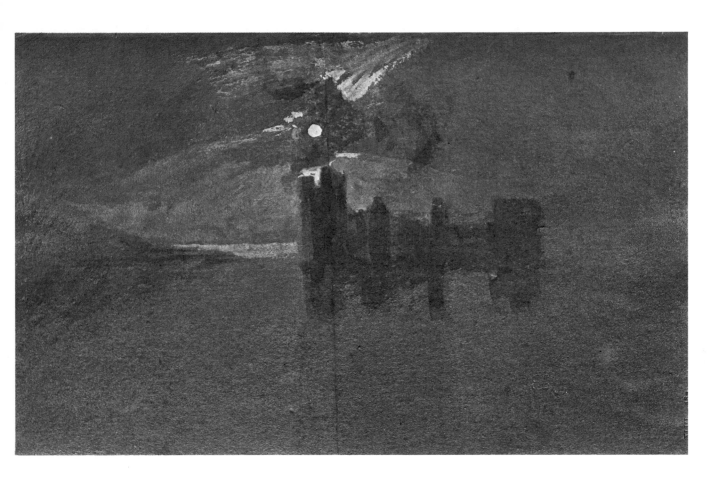

42a 44a 43a Caernarvon Castle

The mountain, folio 48a, is a formalised, experimental version of the sketch on p 65. The composition sketches of Caernarvon are of course, equally, experiments. I do not think they were done by moonlight, though they give that impression. The finished watercolour exhibited in 1799 was subtitled 'at sunset'.*

There are five blue and white studies altogether. Each, to the constructive eye, is a distinct and viable pictorial formula: the simple elements – the blue masses and white sun – are finely balanced, for all their roughness, against the background, where the brown paper is exposed to various degrees by washing away the blue base. A designer at work: and this is extraordinary work to have been done before 1800. The other two are less convincing – false attempts perhaps: or could they be the imitative work of a pupil? Turner had such a pupil at this time, a Mr Nixon, a clergyman. If he were responsible for the

* See the sketches reproduced in John Gage: *Colour in Turner* (Studio Vista).

amateurish, overworked landscapes in this sketchbook this would be a satisfactory explanation of them – and Turner's title would mean just what it says: Academical.

Turner attached the following verse to the title of *Caernarvon castle* in the Royal Academy Catalogue:

'Now rose
Sweet Evening, solemn hour, the sun declin'd
Hung golden o'er this nether firmament,
Whose broad cerulean mirror, calmly bright,
Gave back his dreamy visage to the sky
With splendour undiminish'd.'

Mallet

Mallet was a collaborator of Thomson's.

I don't know where the finished watercolour is – it belonged to a Mr Daniel Thwaites in 1887. It was a great success at the Exhibition of 1799, and Turner was offered 40 guineas for it – 'more than he would have asked' wrote Farington in his *Diary*, always well-informed on money matters.

29 Whitewell

27 Whitewell

Lancashire and N. Wales

Turner was very busy in 1799. Besides getting himself elected
an Associate of the Royal Academy and studying Beckford's
Claudes (which were in London) he had six sketchbooks on the
go. He had sixty drawings 'bespoke', among them some
illustrations to Whitaker's *History of the Parish of Whalley*.
Whalley is near Blackburn.

Turner found his way to Lancashire and worked hard, as he
always did. Some of his drawings were engraved for the first
edition of the book in 1800, but the work of a local artist was
preferred for the engraving of Whitewell, and neither of these
drawings was used. Though he is merely putting down the
pencil-work for a commissioned drawing Turner responds to
the beauty of this remote village on the Hodder, its tiny church
set in a curve of the pebbly river-bed between round-topped,
wooded hills.

The village is hardly any larger today, but the church has been
crudely rebuilt and the barn-like house has become a large hotel.
Instead of the stocks, the centre of the scene is occupied by a
tasteful notice on the church wall, warning visitors not to park
their cars unless they intend to patronise the hotel.

26a Caernarvon Castle

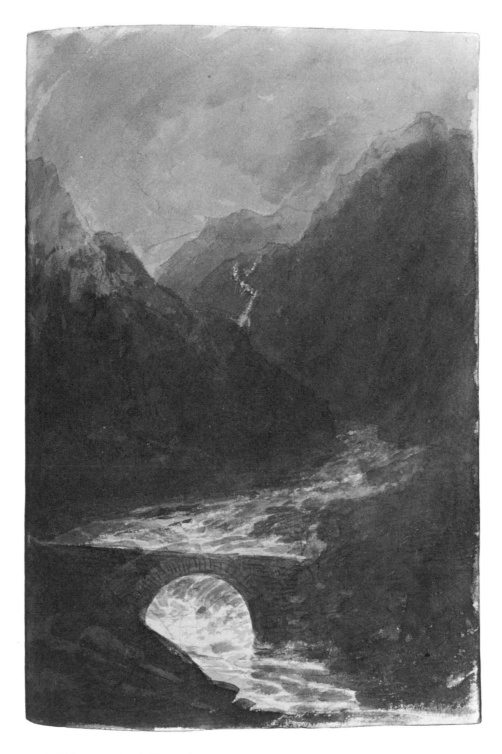

7a Welsh mountains, bridge and torrent

Finberg says that Turner paid a hurried visit to North Wales on his way back via Manchester, though I can't see what evidence there is to suggest this. The pencils of Caernarvon for instance (pages 82 and 83) could have been the factual origins of the compositions on our previous two pages, or they could have resulted from a second visit to check up on details – it doesn't matter. The almost angry style of the mountain valley with its torrent and bridge matches the subject – and closely resembles the style of folio 66 of the North Wales sketchbook, dated 1798 (p 67). Nothing could be closer to the moody greys of Snowdonia than these wild monochrome wash drawings – there are two others in this sketchbook.

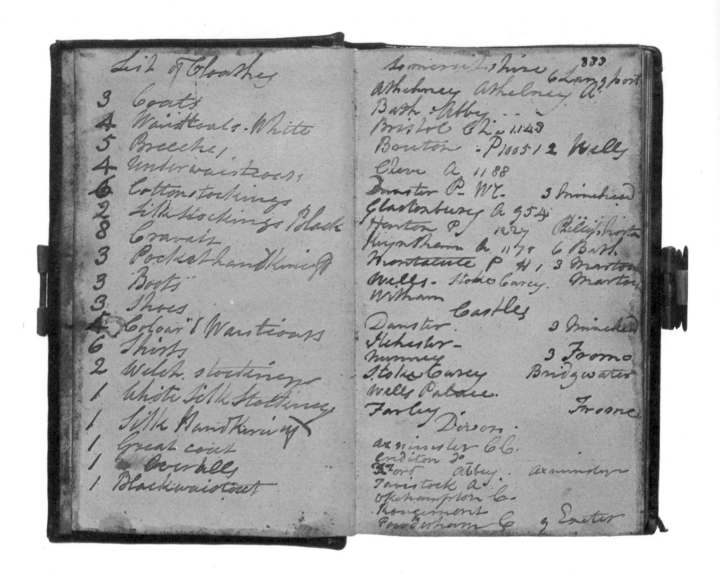

The little book called Dolbadarn is a strange mixture, more a sort of artist's commonplace book than the usual sketchbook or study book. The outline drawing of Snowdon from Beddgelert, for instance, looks more like a note of one of Girtin's water-colours than a sketch on the spot, while some other mountains such as *Glyder Faur* (Turner's spelling) must have been drawn on the spot (perhaps from a coach, pausing briefly) and appear nowhere else.

Some of the mountains and clouds have numbers over them. Obviously Turner had worked out a system of graded tones, but he didn't persist with it. It is easy enough to jot down numbers, but another matter to interpret them later.

There are some copies from classical landscape pictures, a few notes, a wash drawing or two, a couple of miniature sea pieces, a list of places of interest in the West Country, a pen-and-ink drawing of an untypical composition (from a print perhaps, or by another hand) including Dolbadarn Castle. Caernarvon Castle appears several times, apparently now seen from the sea, in evocative pencil tones; so does Conway, in ink. On one of the small pages (folio 37) are notes of a poetic impression worthy of Monet.

Turner wrote some French verbs and pronouns at the front of the book and the very interesting *List of Cloathes* at the back.

106 Snowdon from Beddgellert

101 Study of leaves

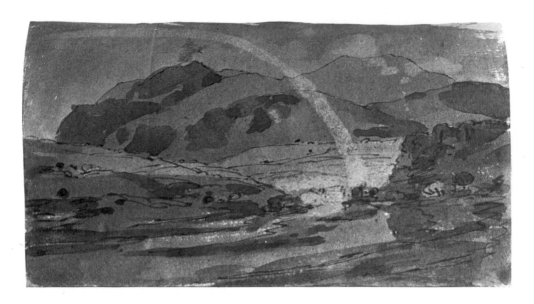

74a Snowdon range, with rainbow

54 Caernarvon

118 Copy of a picture

118a Sea piece

10a *Rain Approaching after Sunrise*

19a Mountains and clouds

37 *One Silver Streak under Bridge*
Sky Light Grey. Windy in the Bottom till nr. Barge. Moon Glimmering

44 Lake of Llanberis with Dolbadarn Castle

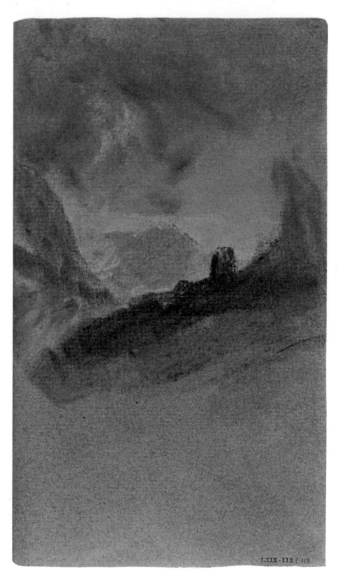

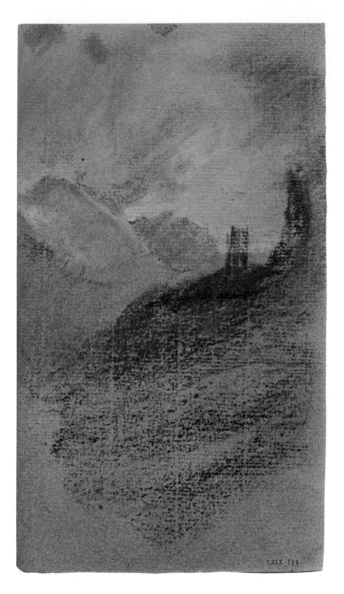

113

109

Studies of Dolbadarn

Finberg, no doubt correctly, dated the book from which these studies are taken as 1800-1802. Some more drawings from it will be found on pages 142, 143. At first sight the pastels may appear to have been done in the studio as part of the process of composing the oil painting. But could anyone do six (there are six altogether) slightly different sunsets from memory? There is no other sketch of the castle from this viewpoint – some outlines in the 'Dolbadarn' sketchbook hardly qualify – and yet, it is possible. Later in his life Turner often demonstrated that he could recall a momentary vision in great detail, and sometimes after a lapse of years.

Here certainly is a moment of vision. I prefer to think of him, not in his studio, but in the chill air of the darkening mountain valley, having returned to the scene with a box of pastels and this book of blue paper. His horse would be nearby, champing

the coarse turf. As the sky changed Turner must have worked very fast, using the coloured chalks as naturally as if he had always used them (though it is clear from the earlier books that they were not his most familiar tools). It would be too dark (as I imagine it) to have used watercolour.

The theme is simple – the cold prison tower against the living sunset sky, yet here Turner has suddenly broken through into a new world of colour and light that he was later to make his own. It does not matter that the painting he turned in to the Academy shows no sign of primary hues – not for years did he make oil his true medium: the first momentous step was taken.

I hope the reader will forgive a paragraph of speculation. Such crises as the one I suggest do occur in the lives of young men – often though they pass unrecognised until later. These pastels may not have been done on a summer evening in North Wales; sunsets are interchangeable. But if they were not drawn in the shadow of Dolbadarn Castle they certainly record an experience in that place – an experience far-reaching in its consequences for Turner and for the story of art. Primitive

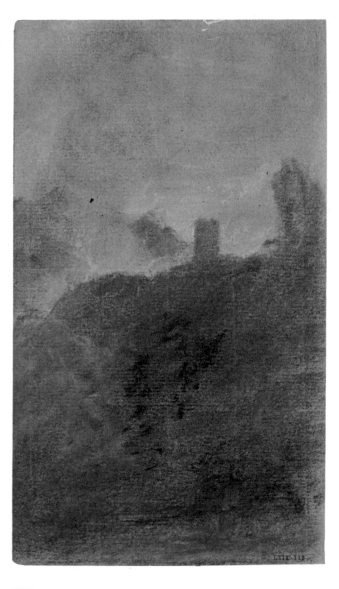

112

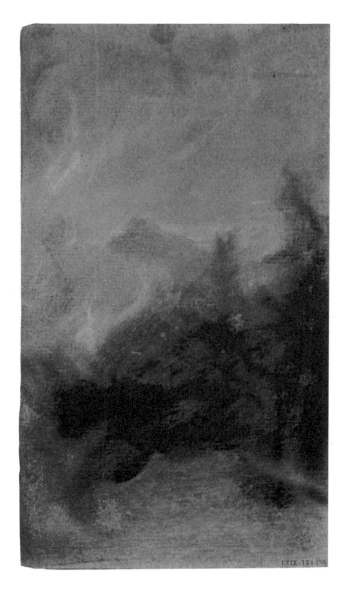

104

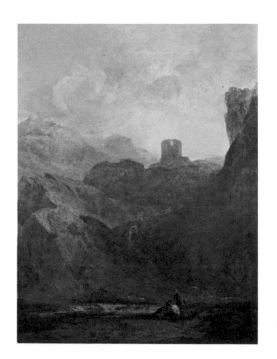

though they may be, these half-dozen chalk drawings done at the very end of the eighteenth century seem to me to contain the first germ of the modern movement, as it used to be called, in twentieth century painting.

Significantly enough, the verse which Turner put in the Academy catalogue was not Milton or Thomson but his own, derivative though it is. The picture, first exhibited in 1800, was submitted as his 'Deposit' on Turner's election in 1802 to the Royal Academy. There it still hangs.

Dolbadarn Castle, North Wales 1800 (Royal Academy)

How awful is the silence of the waste,
Where nature lifts her mountains to the sky.
Majestic solitude, behold the tower
Where hopeless OWEN, long imprison'd, pin'd,
And wrung his hands for liberty, in vain.

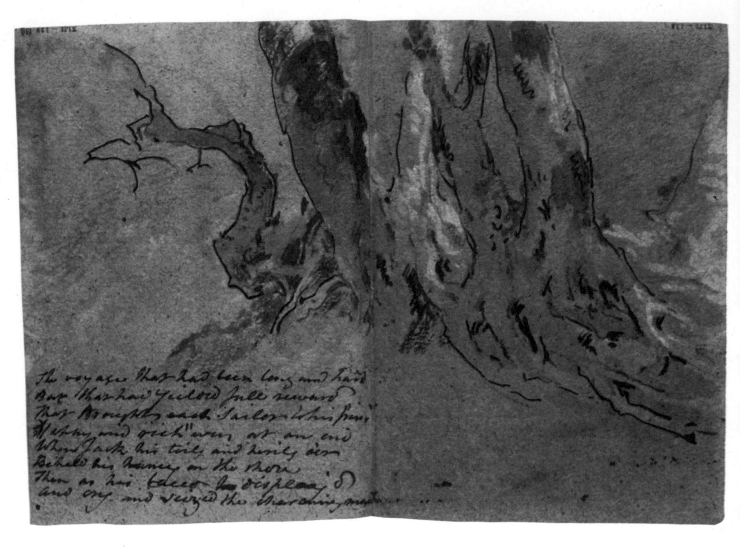

138–9 Tree trunks

Grotesque or picturesque?

The octavo of tinted paper, called by Finberg, 'The Swans',
accompanied the artist from Bristol to South Wales in 1798 and
on some of his travels in the following year. There are some
swans in Indian ink and white chalk, which I think were drawn
at Fonthill (see the following pages) and some bold, twisted trees
which could have been done there or in Kent. Turner was
reported by Farington to have been 'in Kent, painting from
Beech trees' in the autumn of 1799 (after his stay at Fonthill).
The earlier drawings in this book are of little interest, so I have
ventured to take it out of its numerical context.

The tinted paper is used almost throughout to support chalk
as well as pencil: only in the swans and tree subjects are ink
and colour used as well, and in these the style is strong and
confident – the style of 1799. It is hard to realise today that
Turner was bold in more than technique in giving his attention
to gnarled and twisted or bent trees – they were considered
ugly and 'unnatural' at the time, and did not find a place in
pictures meant for exhibition. These are fine, vigorous studies
by any standard: in their time they were stridently original.

Thus did Turner and his Romantic contemporaries transform
the grotesque into the picturesque.

In the year before, as he left Bristol on the Narraways' pony,
Turner must have been persuaded to take down this complicated
prescription – on an endpaper:

Recipt for making an Efficable ointment for Cut . . .
Solomons Seal leaves and Buds
Comfrey Do.
Bay
Elder
Valerian
An equal quantity to which may be added a handfull of Parsley
these herbs must be cut small bruise in a stone mortar boil'd
for some hours in a Bell mold Kettle over a slow fire in a
sufficient quantity of unwashed butter to make the Herbs
thoroughly moist it must stand ten or 12 days after which
strain thro a Cloth, the Juice then to be boiled and well skimm'd
and run into small Jars or Pots.
Given by Miss Narraway of Bristol.

At the other end of the book are some experiments in poetry –
not too promising, but they may tell us something of the way
young Turner's mind worked when he wasn't drawing or

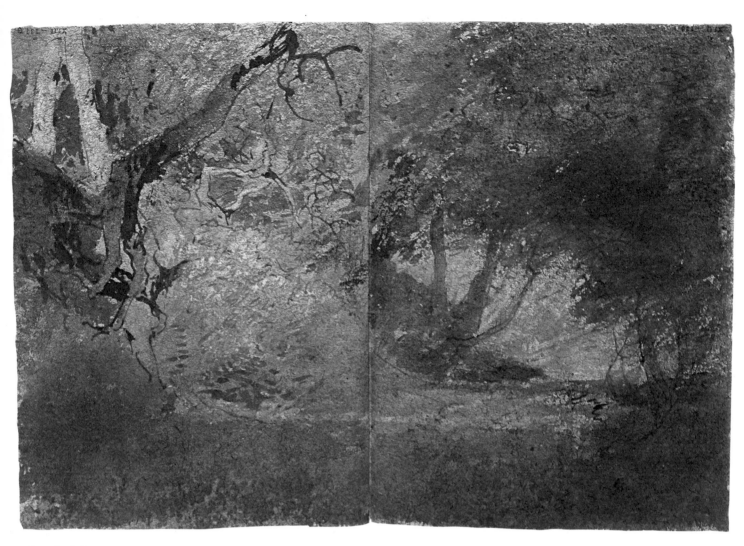

136–7 A glade

planning his life. There are two ballads, their subject the young sailor, his ship beset by storms, sustained by thoughts and hopes of his loved one waiting at the end of the voyage.

The Breeze was fresh the Ship in stays
Each breaker hush'd the shore a haze
When Jack no more on duty call'd
His true love's tokens overhaul'd
The broken gold the braided hair
The tender motto writ so fair
Upon his bacco box he views
Nancy the Poet love the muse
 If you loves I as I loves you
 No pair so happy as we two.

The storm that like a shapless wreck
Had strew'd with rigging all the deck
That tars for shark had given a feast
And left the ship a hulk — had ceas'd
When Jack no more as with his mesmates dear
Who shared their grog their hearts to cheer
Took from his bacco box a quid
And stare'd for comfort on the lid.

. . .

The voyage that had been long and hard
But that had yielded full reward
That brought each sailor to his friend
Happy and rich was at an end
When Jack his toils and perils o'er
Beheld his Nancy on the shore
Then as his bacco he display'd
And cry and seized the charming maid.

There follows a rolling ballad of which every other verse has Nancy rhymed with 'fancy':

6. *Round went the can the jest the glee*
 While tender thoughts rush't o'er each fancy
 And when on turn it came to me
 I heav'd a sigh and toasted Nancy.

7. *Next morn a squall came on at* 4
 At 6 the elements in motion
 Plung'd me and three poor sailors more
 Headlong within the foaming Ocean.

12, 13 Fonthill

14 Swans

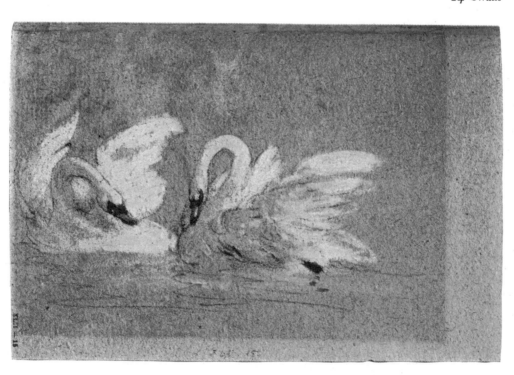

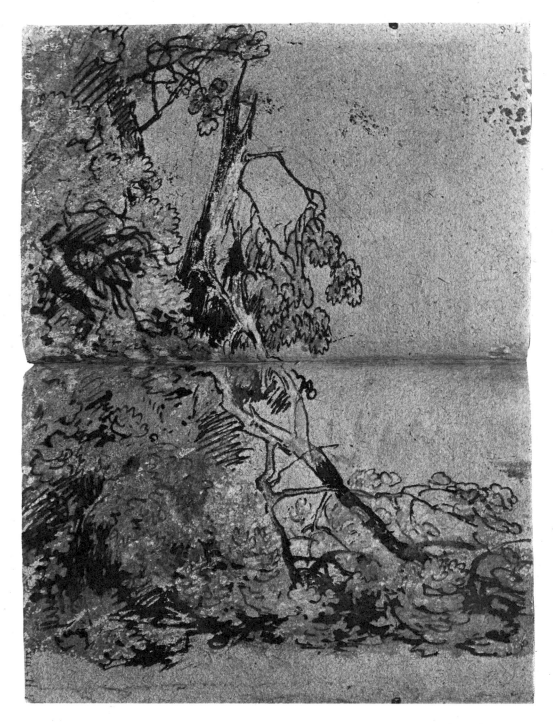

16, 17 Broken trees

8. *Poor wretches they soon found their graves*
 For me it may be only fancy
 But love seem'd to forbid the waves
 To snatch me from the arms of Nancy.

Jack Lindsay, who has studied Turner's verse in some depth
(see *The Sunset Ship*, Scorpion Press, 1966) suggests that the
verses may be by C. Dibdin, author of a haunting
sea-shanty, *Tom Bowling*. But, to me, the bathos, the crudity of
construction and the mis-spelling are all signs of the literary
Turner.

Fonthill

Turner spent three weeks here in 1799, working on the sketches for a series of commissioned watercolours. Fonthill was a large park, rambling, wooded, to the south-west of Salisbury Plain, where the very rich and very eccentric William Beckford was building his Gothick 'abbey'. This was to be the Romantic equivalent of a rural skyscraper in its effect on the landscape, and though a maturer Turner might have done great things with such an impressive building he seems to have a lot of trouble at this time in finding a suitable setting for it. He tries it from all angles and at all distances: framed by a rustic cartshed, glimpsed between trees, even dwarfed by a great aqueduct across the foreground. He is frequently distracted by picturesque fallen trees and fighting swans.

Two of the sketches of the unfinished 'abbey' are the detailed architectural outlines reproduced here. Turner has now a fantastic skill with the pencil. One must admire also his

scrupulous refusal to be awed by this hyperbolic edifice, so that he has left the most accurate records of the building – which, a few years later, fell down in a thunderstorm.

Engraving by Rutter: *Delineations of Fonthill*

5 Fonthill Abbey

The coloured page (folio 10) of the large Fonthill sketchbook
represents a moment of inspiration at sunset – inspiration quite
lost in the elaboration of the finished version now in the
Whitworth Gallery, Manchester, where there is another,
'East View . . . Noon', even duller. There were seven views in
all, and at 35 guineas each (the total in modern terms would
be over £2,000) this was not a commission to be refused –
especially from the great Beckford who had just bought the two
Altieri Palace Claudes which Turner so wished to imitate.

14 Trees beside a lake, with swans

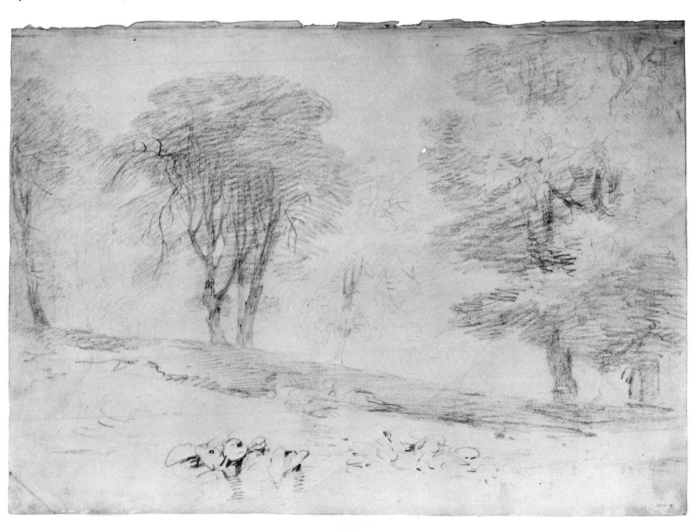

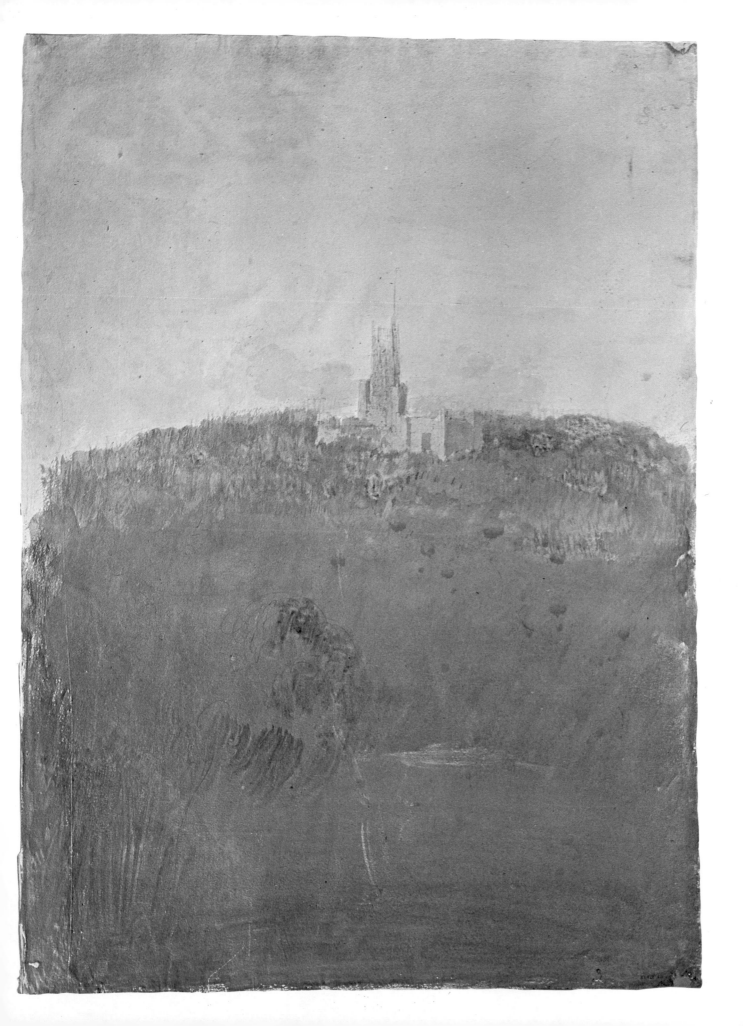

20 Boys asleep under a fallen tree, with swans fighting

 William Beckford, that 'connoisseur of the sublime' (Finberg)
has so far spent nearly twice his annual income (£155,000,
according to Farington,) mostly 'from Jamaica' on his Gothick
abbey – somewhere on the horizon in this great, neglected
estate it stands half finished. Here three boys, whose labour
may be worth 2s 6d a week, lie under a dead tree trunk. Some
swans strike attitudes in the river. Turner, squatting with his
large sketchbook, observes. . .

6a, 7 Salisbury Cathedral from the South, pencil

21 Landscape, chalk

Salisbury

Another rich patron was Sir Richard Colt Hoare who commissioned in this year twenty drawings of Salisbury. The sketchbooks show no more of Salisbury than the little drawing shown here. Various subjects in Salisbury were drawn on large sheets of paper, as were some Oxford scenes which also do not appear in the sketchbooks. The Oxford drawings occupied Turner at various times, being commissioned by the Clarendon Press for engraving in the Oxford Almanacks.

The little sketchbook which Finberg labelled 'Salisbury' contains about twenty pages of notes in pencil or chalk, mostly of boats, and 60 blanks. In the back endpaper are notes for a song, beginning:

Love is like the raging Ocean
Would thou sway its troubl'd motion
Woman's temper well

The sketchbook also contains Turner's new address: 64 Harley Street.

69a A sunset or sunrise, chalk

68a

Turner's method of painting-by-numbers was probably no more than a way of indicating relative tones – the internal chiaroscuro of the picture and not a rigid system of standard tone values. Colours, where there could be doubt, are noted by letters – here, B identifies the sky as distinct from the clouds. In the Welsh drawings that were similarly treated (p 90) we have S for silver, G for grey and L to pick out the lightest bit.

The second drawing introduces the element of time – and makes the whole incident real and exciting.

LI–G Study of a sailing boat $20\frac{1}{2} \times 17$ 52×43 cm

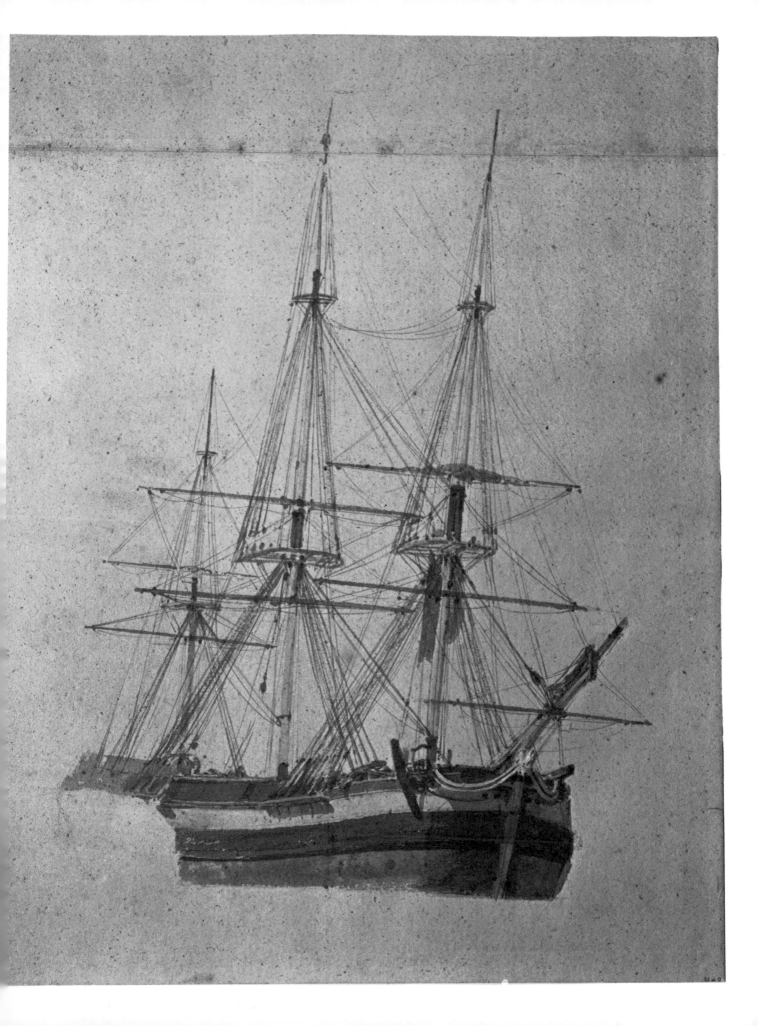

'Guisborough Shore'

Guisborough is five miles from any shore, but Turner's title
merely means: drawings done on the shore while staying at
Guisborough. He could not have lodged at Redcar in those days
and Saltburn-on-Sea didn't exist – nor did Middlesbrough.

This book is of cheap tinted paper such as Turner used for
rough work – the blue is not a specially prepared wash. The
twenty or so vigorous drawings of breakers and rocks probably
represent an unpremeditated attempt to study the violent
movements of water in this way. Turner must have been
gathering material for a sea shore picture, but it does not yet
seem to have taken shape in his mind.

The chalk used for highlights has faded and the pencil is
rubbed – there's not much to see, but I reproduce a sample,
more to show the intention than the achievement.

Turner returned to a similar shore with the prepared paper
of the 'Dunbar' sketchbook.

7 Whitby

Turner in 1800, by George Dance. (Royal Academy)

Helmsley to Scotland

Finberg regarded this book and those numbered LII, LIV, LV, LVI, LIX and the 'Scottish Pencils' (LVIII) as belonging to the Scottish tour which Turner mentioned to Farington, on 19 June, 1801: 'starting on the morrow, to last three months'. In the event the tour doesn't seem to have lasted half that time, and I think seven books, mostly full and one of them large and laboured, too many to have been carried about in as many weeks, even though the quantity of work is not untypical. The books cannot be precisely dated from internal evidence and as Turner's movements in the previous year are not accounted for it seems at least possible that there were two separate journeys northwards in successive years. The varying styles of drawing bear this out.

At any rate the Helmsley book – *Helmsley to Newcastle. Northumber1d Tweed*, runs Turner's label – contains work differing sharply in style and approach from that of the Scottish books, though it clearly forms part of the record of a journey to Edinburgh. Some drawings, like the view of Whitby, above, could even date from the first visit to these parts in 1797.

If we may assume that Turner arrived in Yorkshire in the spring of 1800 (the snowy hills overleaf make us think more of April than a late June) we must visualise a young man with the world at his feet. He was just turned 25, the youngest A.R.A., and he left behind him in London a very successful show which

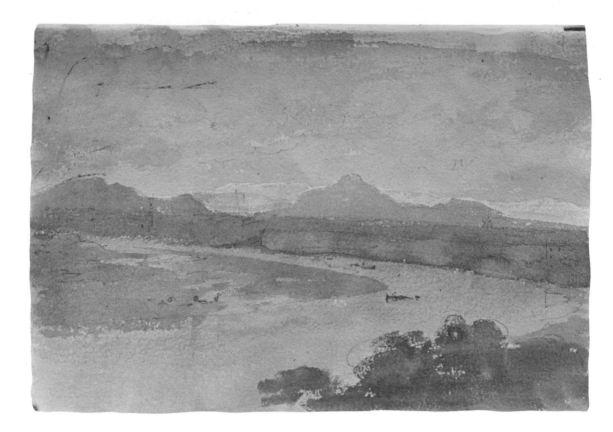

14 River with distant mountains

had added to his fame and earned him a total of 400 guineas, as
well as leading to a valuable commission. He had a mistress,
perhaps even a baby daughter (Evelina was married by 1817 so
she must surely have been born around 1800). He now had an
address in Harley Street. He had saved while living with his
parents and was quite well-off. He had also (most important in
the wilds of the North East) the constitution of a mountain
pony.

His mood may well have been buoyant and receptive. The
drawings here are full of air, light and movement. He is able to
modify his usually rather unexciting travelling palette in
response to a landscape of chill beauty — the river with distant
hills, folio 14. In the two sketches of Durham, opposite, he can
keep pace with the shifting clouds, so direct and spontaneous is
his handling of watercolour.

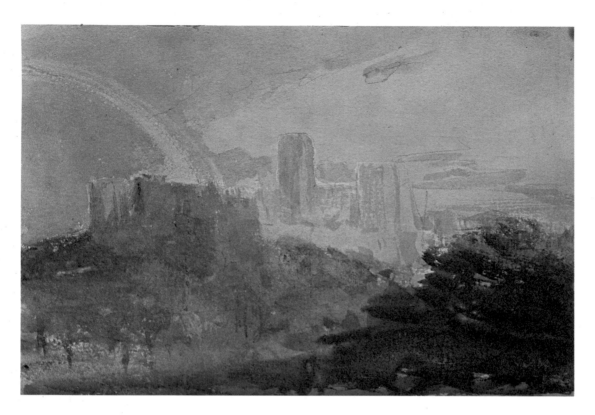

97 Durham Cathedral with rainbow

98 A few minutes later

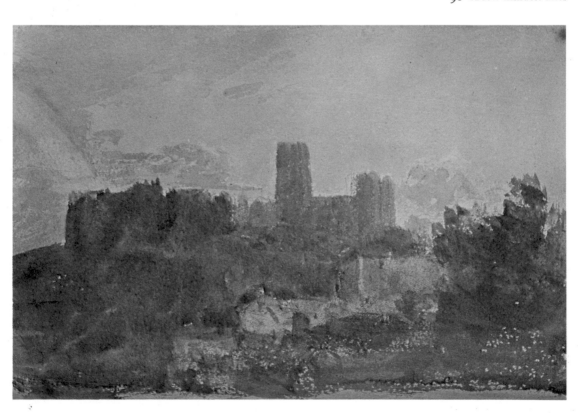

13 A market cross with figures (Helmsley)

11

The main street of a north-eastern town in 1800.

Such busy scenes are rare in Turner's early sketches. Human figures are still a problem to be worked out in the studio. In the sketchbooks they are insect-like, or (as here) costume studies unrelated to any landscape, and there are not many of either sort.

The sketchbook contains some drawings on the Tweed, including Norham Castle which Turner had done in water-colour for the 1798 Academy and was to paint again in 1824. There is a rough pencil of Edinburgh – perhaps a 'first view', like the one of Oxford a decade ago.

The lists of travelling expenses are from the inside back cover. They indicate a wandering route round the coast of north Yorkshire; a detour down the Tweed: Turner was in no hurry to reach Edinburgh. The two lists, south and north of the Border, must have been written at widely different times – the

endpaper

12	10	4	6			
			3			

	£ s d				
CH (coach?)	1 11				
H (elmsley)	17				
Pick (ering)	8 6				
Scar (borough)	1 17 3				
Wit (Whitby)	1 12 6		4 13 9		
Gis (Guisborough)	8		1 12 6		
	6 14 3		8		
Stock (ton)	10 4		6 14 3		
Sedg (efield)	3 6				
Durham	2 0				
Newcas (tle)	11		10 5 1		
Morpeth	14				
Weldon B (ridge)	8				
Alnwick	12				
Wooler	9 4		12 8 5		

	£	s	d
Cornhill		10	0
Berwick		9	6
Press & Dunbar	1	2	0
North Berwick	1	4	0
Addington		13	6
Dalkieth		16	6
Edinboro	7	18	1
Qunsferry		8	
Lithgo		12	6
Cumbernald		9	
Glasgow		12	2
Dumbarton		8	6
Luss		14	
Arraque		9	6
Cairndow		15	6
Inverara	2	4	10
Dalmaly		10	9
	20	3	4

change in Turner's handwriting is great enough to span a year or more and corresponds to the change in his use of the pencil – and to a psychological change.

The higher costs in Edinburgh may be due to a longer stay, as Finberg suggested, or they may be the price of a coach and driver for the round trip in the mountains, or a bit of both. The current price of a hotel room with all meals was six or seven shillings. Turner's route can be followed beyond Dalmally in the Scottish Lakes sketchbook (LVI).

93a A mountain road

Moods of the sea

The same size as the Helmsley book but made as a 'landscape' shape and with most of the pages washed brown-pink, this was called 'Dunbar' by Finberg but actually labelled *Scotland* by Turner himself. Obviously tinted paper was intended to aid the rapid rendering of tones, whatever the local colour of the subject, but Turner is quite happy to work a full range of colour into the tinted ground in the drawing of Whitby Abbey from the beach, overleaf. The warm ground colour permeates the whole of the drawing – it heightens the temperature of all the colours, gives them a density recognisably British, the result of heavy skies and humid air and, in this case, salty spray. Here is another example of Turner's developing sensitivity to colour. Painters before him, especially the Dutch, had rendered effects of dull weather – but much more literally. Whether Turner used the pink ground by choice or by accident he exploited it for a perfectly authentic richness of effect, working as he was still with a traditional palette.

This is a book of ruined abbeys and castles, and rocky coasts. The artist who had made his reputation with watercolours of Gothic buildings seems now to be searching for scenes of a deeper, wilder romanticism. But he does not find what he is looking for, even in the remote Tantallon Castle and the Bass Rock. The drawings on the seashore are best. Throughout it is the sea which inspires and obsesses him – water is Turner's favourite

North-eastern England, detail of a map from William Faden's *General Atlas* 1801. Bold dotted lines indicate coach roads. (Royal Geographical Society)

83a–84 Whitby Abbey

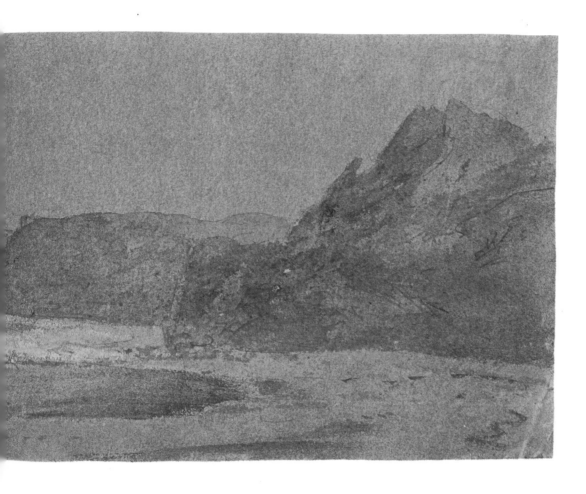

element in whatever shape or mood. The painter who was later
accused of using 'tinted steam' as a medium is here confronted
with his element in its most impressive and challenging state.
The studies of breakers on the following two pages are not just
pieces of brilliant analysis and virtuoso execution, convincing
even to our camera-conditioned eyes: they are poems of
exultation.

Turner's sudden attack on the difficulties of drawing waves
was probably due to the commission for the 'Bridgwater Sea
Piece' – *Dutch boats in a gale* – being on his mind. But work-
ing here with the wind in his face he found the inspiration
for the dramatic 'Fishermen on a lee shore' of 1802. He was
able to identify with the struggles of fishermen landing their
catch. These pages of breakers were cut from the book and
almost certainly used (in reverse) in the composition of the
painting (page 15).

Turner was also mastering the quieter rhythms of the sea, as
in the seascapes on pages 120 and 121.

The whites are a mixture of chalk and scratching-out – the
latter, according to a tradition, with the aid of his sharpened
thumbnail.

110a, 116

116a

LIV 116 1/6

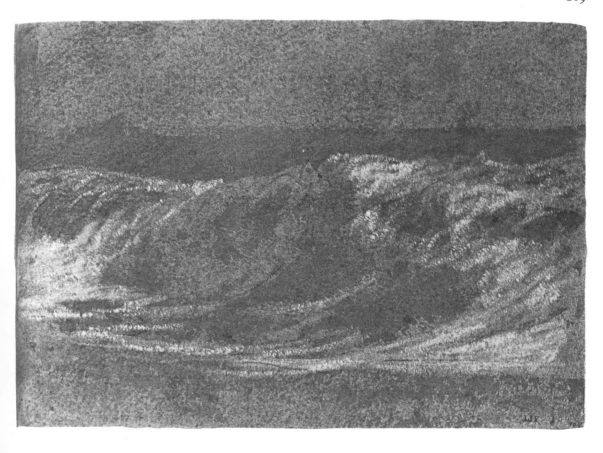

95a–96 Scarborough

99a A castle

96a Sunrise on the N.E. coast

10 Edinburgh from St Margaret's Loch

Edinburgh

A complete change of mood characterises the pages of the slim
paper-covered book labelled 'Edinburgh'. The winds of the
coast give way to mist, and Turner's search for the Romantic is
centered on Edinburgh castle, which he approaches in a more or
less contemplative way from practically every angle. There are
many understated pencil notes and four almost monochrome
wash drawings. These last achieve an unusual serenity.

I have chosen two of them. One of those left out struck me
as a discarded attempt at folio 10. The other is reproduced (and
flattered) in Butlin (see list of books, p 156). It is a view of
Edinburgh castle, a creamy dawn sky reflected in the Water
of Leith. Apart from the sky the colours are muddy and
brownish and the drawing could be called overworked in our
context. Between this drawing, very much in the style of the
Helmsley book (p 111), and the two reproduced here Turner
managed an enormous leap forward. Instead of a landscape
represented in an atmospheric way we have landscape *used* to
represent atmosphere. This is the mature Turner at last.

The rest of the book is in pencil only. There are some
sketches at Roslin which don't amount to much, and others
around Edinburgh. But one drawing breaks entirely away from

Turner's habit up to this time (folio 25 opposite). It is a pencil
composition in its own right – like the Welsh waterfalls of 1798
(pp 68, 69), perhaps – but extremely formal in conception; it
might pass as an early Paul Klee or a Cezanne. It may seem a
fairly conventional scribble to modern eyes, but nothing like it
had been done before.

It must be accepted that Turner's pencil notes have now a
different purpose – or a range of purposes, as I shall try to show.
In previous sketchbooks the pencil work is very largely of
architecture in outline – it could be coloured in, or, as was more
usual, copied to a larger scale and incorporated in compositions
intended for exhibition. These were highly artificial concoct-
ions heavily worked and cluttered with conventional, often
grandiose, groups of foliage. This was what he had to get away
from, now he was a serious painter. In the drawing of cottages
by the Water of Leith he is not laying down the lines of a
future ritual; he dares to interpret his subject in terms of the
simple materials he has to hand. This sketch contains the
confident architectural detail as well as the vigorous, almost
careless, handling which we have noticed in the trees of
Fonthill and the Dunbar waves, but it is much more than either
of these elements. It has an abstract quality – a truly *abstracted*
quality, for here Turner has at last become master of his
material and is able to select just what he requires for his
purpose.

24a–25 Houses by the water of Leith

7a, 8 and 9 Edinburgh Castle and St Giles from near Holyrood

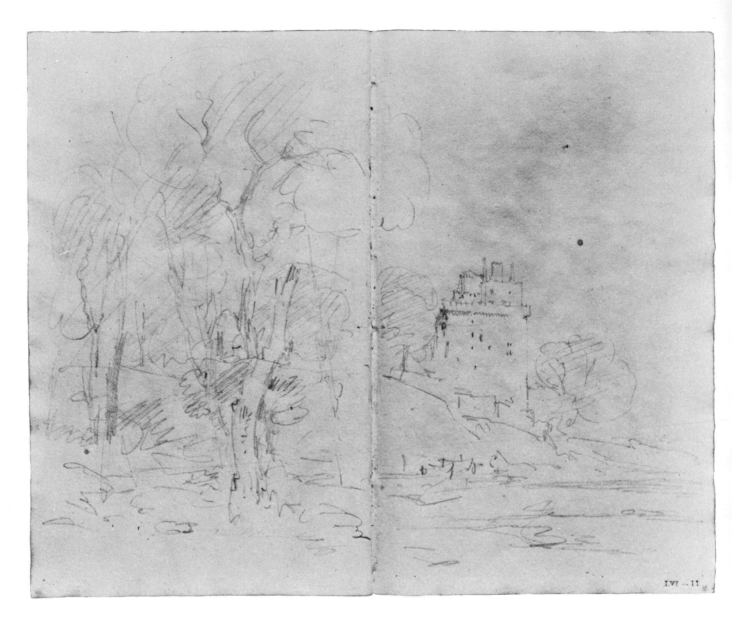

Linlithgow

In the Highlands – 1

The notebook to which Finberg gave the discordant title of 'Scotch Lakes' is an upright octavo of some 384 pages – like a long novel, but instead of narrative it is full of pencil scribbles. The effect is at first confusing: one asks, is this art? Some of it most certainly is – for the rest, it is only Turner getting the lie of the land. His apparent hurry and his superficiality are

81a, 82 Ben More

understandable – he would want to see as much as possible – and
not so insulting to the glories of the Highlands as his biographers
have thought. 'Doing Scotland in nineteen days' he emerged
with a complete record, labelled and consecutive, of what he had
seen – a considerable range of potential material. This is the
first of Turner's sketchbooks that he used methodically,
working through from one end to the other.

The drawing of *Linlithgow* is more detailed than most, the
one of *Ben More* typically understated – but in this case it is a
masterly understatement, complete in its simplicity.

98a–99 Kenmore

Turner's tour took him from Edinburgh to Dunbarton, up the side of Loch Lomond to Luss and then to Inverary and Dalmally as shown on page 113. He then turned eastward to Tyndrum, Killin, Loch Tay and Kenmore, where he paused long enough to do some lovely trees. His draughtsmanship at this time has acquired a strong feeling for three-dimensional modelling – more than hinted at in Wales in 1798 but now coupled with a sinewy line – so that we sense the movement of these branches in the wind, not just in space.

LVI—100

99a–100 Kenmore

119a–120 Blair Athol

The little glen at Blair Athol is one of a pair of fascinatingly sculptured drawings where the sense of space is achieved by well-placed accents, while light and air are suggested more by what is left out than by any labour.

This was the most northerly point of the journey. Turner then travelled south by Dunkeld, Monzie Castle, Stirling, Bothwell Castle and, quickly, to the Solway, his drawings ever more superficial as he went.

121a–122 *Blair Athol L towards Kilicranky*

135a–136 Near Dunkeld

184a–185 Gretna Green

Three lightning sketches of the smithy at Gretna Green and he had done with Scotland for the time being: *18 of July left Edinburgh and on the 5 of August finish'd this book at Gretna Green.*

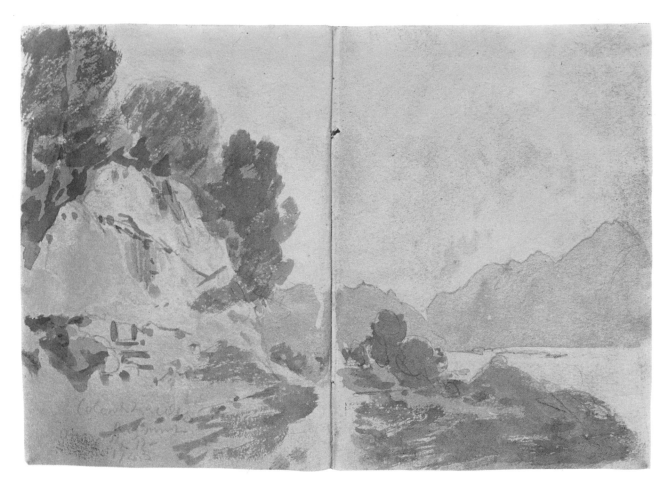

3a–4 Monument at a loch-side

In the Highlands – 2

The 38 subjects of this book of coloured paper – the pages washed with slaty purple and nicotine brown – are not far from the route traced by the captions in the previous, black-and-white, notebook, but there seems to be no other connection. Its closest links are with the Scottish Pencils, no less than fifteen of which are based on sketches in this 'Tummel Bridge' book. The title is meaningless, being based by Finberg on some guesswork of Ruskin's about one of the subjects, but a name once given is hard to change, especially when the alternative is a Roman numeral. The subjects that can be identified in this book take us no further than 40 miles from Glasgow.

Why no further? There is a tenable theory: Turner chose the area of Loch Long and Glen Coe for his composition studies of 1801 (?) as being the best place he had seen on his 'nineteen days' tour of 1800 (?). Why go further? The central mountains were perhaps too uneventful, the eastern passes too bosky, for his needs. The theory enables us to divide the Scottish sketchbooks thus:

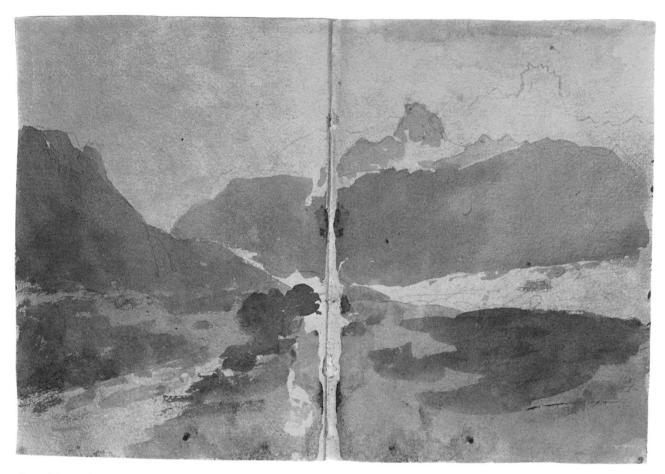

8a–9 Mountains

style: topographical vigorous hasty media: colour or line	1800	Helmsley (contains a distant view of Edinburgh and lists of travelling expenses – some drawings possibly done in 1797 Dunbar
	?	Scottish Lakes

styles: reflective, serious, or purposeful, pencil and monochrome wash	1801	Edinburgh Tummel Bridge Scottish Pencils

 The 'Tummel Bridge' book, besides providing many
subjects for the Scottish Pencils is also linked to them by
colour – the pale brown-grey, which Turner explained to the
credulous Farington as made from ink and tobacco juice.

 On several occasions I have looked through these 60 'Pencils'
– they are a sort of sketchbook since they could all come out of
sheets measuring 14 by 19½ inches. Each time I am struck
afresh by their, for Turner, uncharacteristic monotony and the

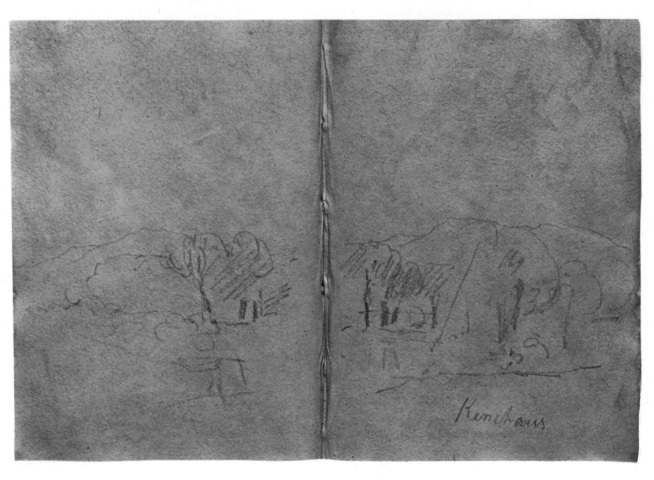

21a–22 Kenchaus

laborious way in which the tones are built up by pencil shading. Then, forgetting or temporarily accepting these conditions, I note some impressive handling of distances (it is not *easy* to represent the scale of mountainous country) or a certain truthful quality of light – Turner's *forte*, after all. But looking on through the collection I am soon overcome by the general gloom. No doubt in 1801 brown was more desirable – indeed it was, and Turner returned to it in richer tones for his *Liber Studiorum* etchings, attempting to emulate the luminous sepia of Claude Lorraine. We can only be glad that, usually, spontaneity won the day in his early sketches, as it did, more consciously sought, in his later watercolours.

Farington records that Turner planned his Scottish tour of 1801 as being 'with a Mr Smith of Gower Street'. Then Turner postponed his journey because of 'imbecility', whether his own, his mother's or Mr Smith's we do not know. Those who cannot accept the doughy modelling of some of the following drawings may like to attribute them to Mr Smith or to 'imbecility'.

However, in spite of the unfortunate reaction they cause (and both Ruskin and Finberg used the adjective 'dull') these drawings did for Turner what he meant them to do. They are 'finished', that is, completely worked out, yet they do not rely on the conventional framework of foreground detail that supports most of his finished watercolours before this date. Turner's capacity for taking pains had moved him one step further on.

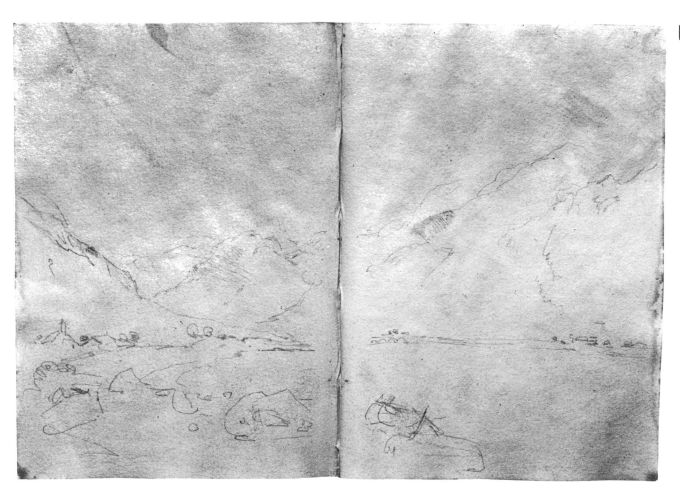

14a–15 Loch Fyne

LVIII (Scottish Pencils) 7 Loch Fyne $11\frac{3}{4} \times 17$ 30×43 cm

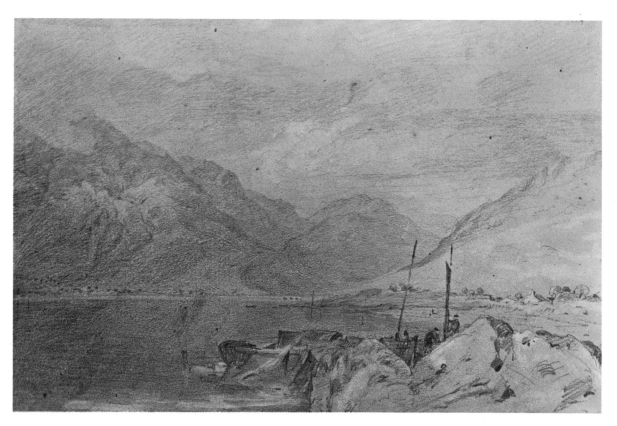

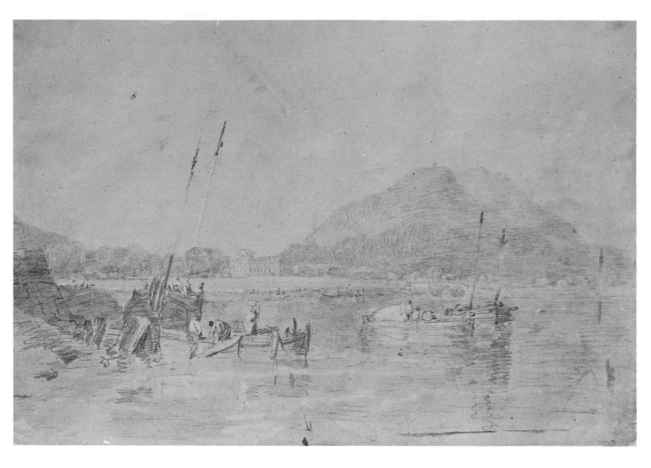

9 Inverary Castle 13 × 19¼ 33 × 49 cm

48 Sheep on a road over a hill 11½ × 17 29·2 × 43 cm

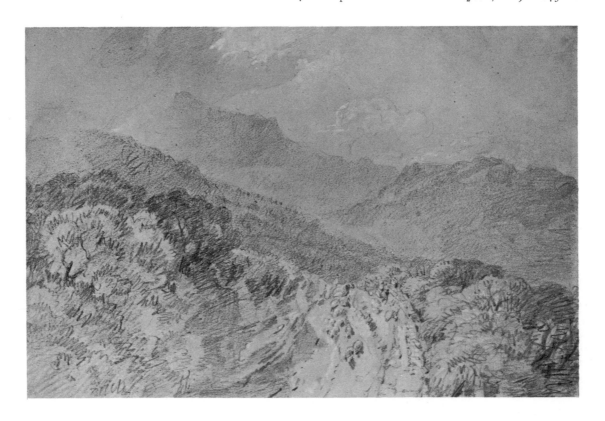

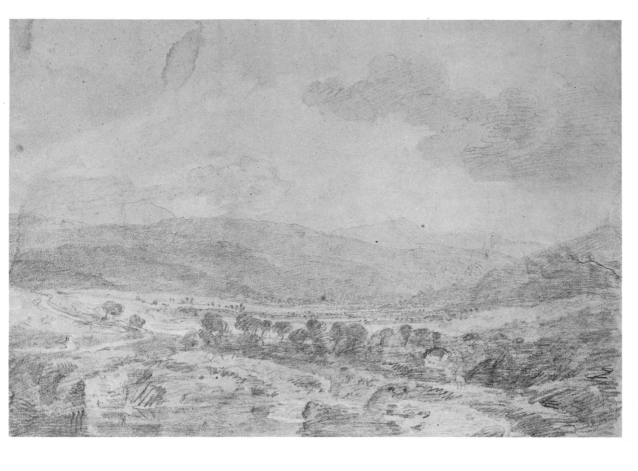

24 A winding river and mountains $13\frac{3}{4} \times 19\frac{1}{4}$ $33 \cdot 7 \times 49$ cm

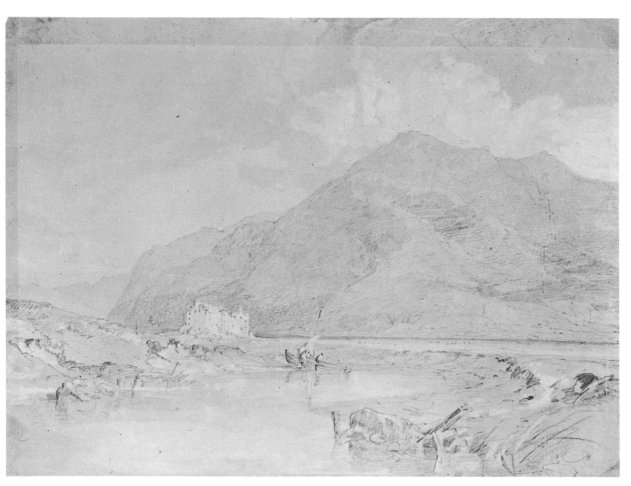

16 Kilchurn Castle, Loch Awe $14\frac{1}{4} \times 18\frac{3}{4}$ $36 \times 47 \cdot 5$ cm

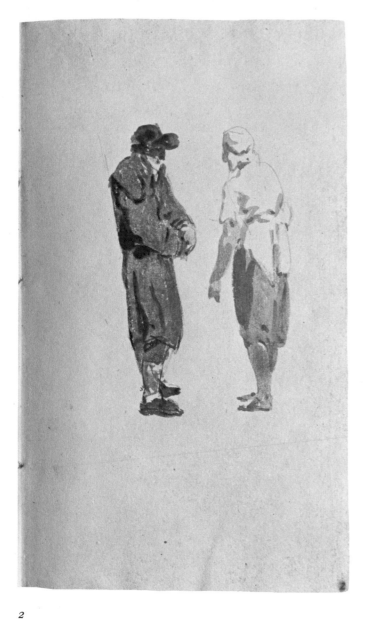

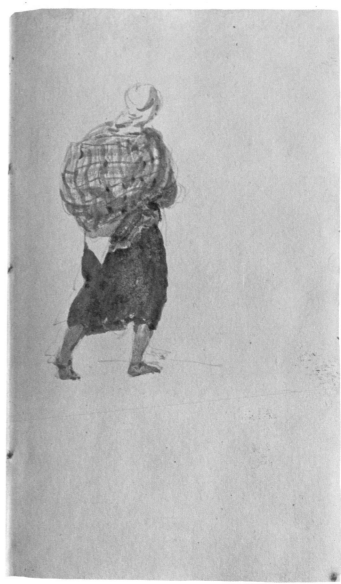

2

4

Scottish figures

So labelled by Turner, this is a small upright octavo,
containing 164 empty pages and seventeen drawings like these,
some only in pencil, showing Turner's interest in human
subjects flagging, as before in the Midlands. The drawings have
a certain awkward charm – and here provide a note of relief.

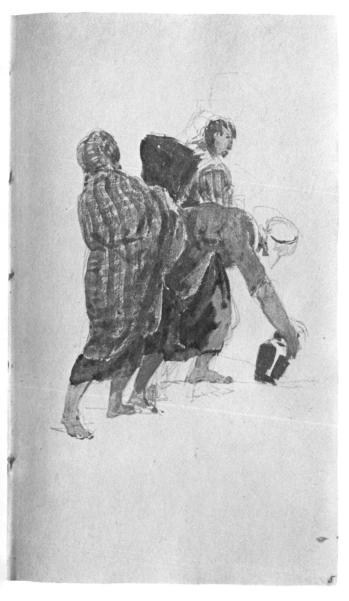

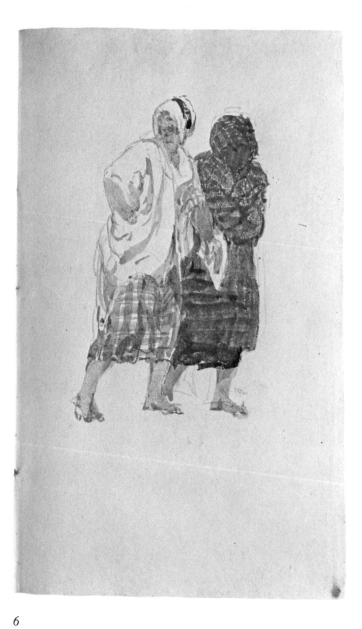

5

6

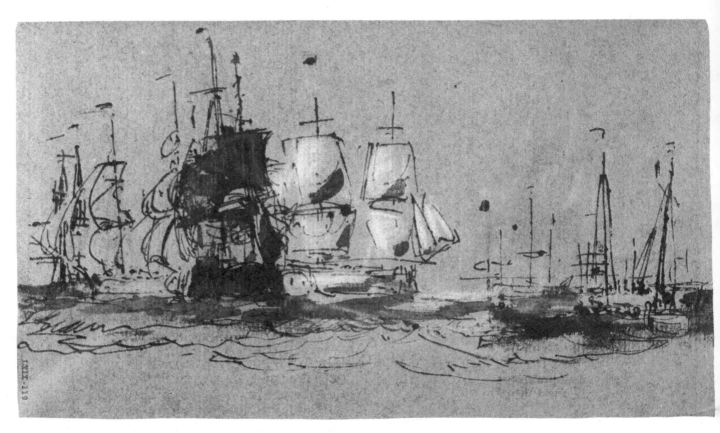

119 A sea piece

102 Castle on a hill, pastel

121 Landscape, pastel

Studies for pictures, 1802

A fat book of thin blue paper the same size as a modern text-book, this is not a sketchbook or a notebook, but a collection of a hundred serious studies for paintings. It contains the six studies of Dolbadarn Castle of which four are reproduced on pages 94–5, studies for figures in the 'Plagues of Egypt' pictures, and numerous arrangements of groups of ships such as those in the Egremont sea piece (page 154). Blue paper was habitually used by Turner for working out his compositions – the same paper is used in the large 'Calais Pier' study book, reproductions from which appear on the endpapers. The blue paper loses its colour very easily.

The busy shipping scene above is in the mood, if not the final form, of the Egremont sea piece, *Ships bearing up for anchorage.*

The castle on a hill rising out of mist is a forerunner of many luminous crags up to the famous *Rigi* series of 1842. This drawing appears on a page next to the Dolbadarn studies and may be a sort of coda to them, a Dolbadarn become symmetrical and symbolical in the afterglow. Anyway, it is a fine drawing with its tenderly blended pastel.

The other landscape is unique in this decade of Turner's working life: it is green! Turner is supposed to have disliked fresh green – but for that matter Mozart is supposed to have detested the flute. Is this, admittedly superficial, sketch an example of what Turner detested in the landscape? I think not.

Whatever the truth of the artist's mental block about green – and of the fastness of his colours – it is in keeping with the seminal character of much of the work in this study-book that this page should look forward to the next decade – to the out-door oil sketches started in 1806. Apart from this, in the context of the early sketchbooks it can only suggest that a number of the early watercolours and drawings may well have been a lot brighter than they now appear: for pastels do not fade.

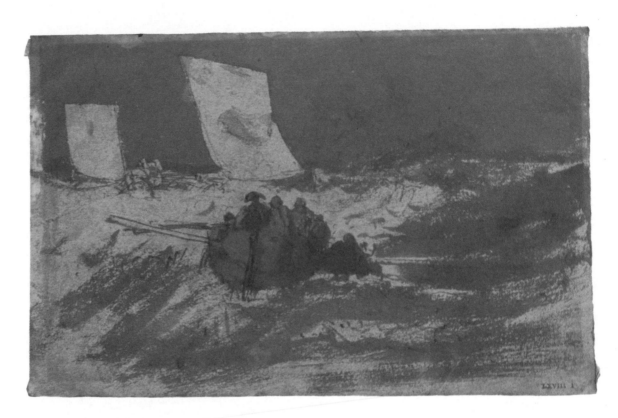

two of the 16 studies 'On a Lee shore'

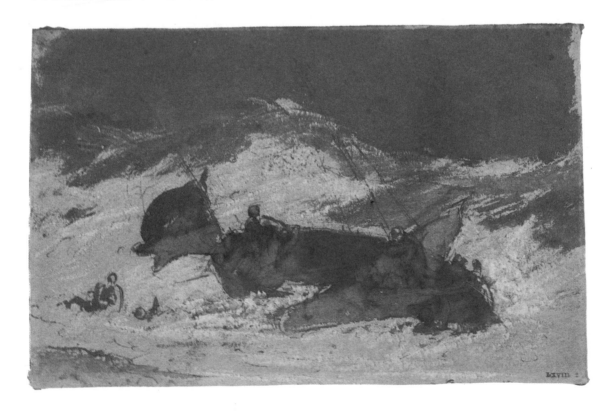

2 A sea piece

4 Dock leaves

Small study-books

'Egyptian details' gets it name from a few crude notes of ancient Egyptian deities – crude perhaps because their sources, at this early stage in Egyptology, were somewhat primitive. There is also a Greek figure for good measure. There are some slight clouds, some fallen trees, and a building which might be Fonthill Abbey; a ruined crypt, a castle, some weeds and a dog – and 140 blank pages. At the front of the book of coarse blue paper are the two pages reproduced above.

The two 'Lee shore' notebooks are of only sixteen pages each. Turner seems to have taken them to the shore purposely to sketch the launching and beaching of some boats in a rough sea. We may guess that he was already at work on the 'Lee shore' painting.

As I have suggested, this picture must have been conceived on the North-east coast of the 'Dunbar' book (pages 119, 120). The breakers of the drawings almost match those in the painting, a reproduction of which is on p 15. As he drew, in the wind and spray, Turner must have thought how to express the drama in human terms. A composition merely of boats, waves and sky could not express such a theme, and for the first time Turner is led to compose with active human figures. In these two notebooks he collects the material he needs. The drawings vary from pen scribbles on the spot to the rather well worked out illustrations reproduced here.

56a Rowing boat

The facility of the master

The subject of Jason is appropriate for the young Turner, but the painting itself is a miserable phantasmagoria. The boats here have nothing to do with the picture, first exhibited in 1802 and now hidden somewhere in the cellars of the Tate. Turner described it later as 'an old favourite with some' – the 'some' meaning himself – and he engraved it for the *Liber*, but it remains dark and difficult, interesting only as the first of his 'monster' pictures. A single sketch for it on the first page of this book gives the excuse for the name; but the sketch is hardly decipherable.

That drawing apart, the few sketches in this book are remarkable for a new professionalism of technique. They are almost surely later than 1802, and later therefore than the period covered by the present work. In the drawings of boats, wash is used to achieve modelling, outline and shadow, all in the minimum of touches – the almost casual facility of the master.

The pencil landscape shows Turner's note-taking style mature in its command of a large range of expression. Tonal emphasis, transparently clear line-work, bony symbolic pattern, some rubbed-in subtleties of gradation: all are combined with precision and vigour. The drawing speaks the language of the twentieth century – the painter's notes to himself turn out to be messages to us, while his paintings are slowly mummified into the History of Art.

But Turner is still a humble student of nature and fact, particularly where they may be useful in a composition. The page of *Laurel* is one of three such botanical ones, the others being of *Larch – light green, rather cold, stem brown and knotted, bark smooth* and *Horse-chestnut – full yellow green where young, but darker more advanced.*

Ruskin wrote on the wrapper in which this book came to him for assessment after Turner's will was settled: 'An early book with half a dozen sketches of some interest – but poor subjects'.

55a and 61 A hoy sailing

4 A stormy sky

We are near the end of Turner's period of insular youth – he was soon to travel abroad. The few sketches in the 'Jason' book, being probably later than 1802, give us a glimpse of a Turner freed from the preoccupations of this period.

In this year he was elected an R.A. He sent in his pictures from a new address, 75 Norton Street, Portland Road, which is supposed (by Jack Lindsay) to have 'served as the basis for domestic arrangements with Sarah', his mistress, who lived round the corner in Upper John Street with her four children and the baby, Turner's daughter Evelina.

In July 1802 he made his first Channel crossing, to visit Switzerland and Paris. He did 400 sketches in France and Switzerland and spent a month in daily study at the Louvre, making copious notes on the methods of the old masters. He returned to England in the autumn.

Girtin had preceded Turner to Paris, returning to England in May of this year. He died in November and was buried at St. Paul's, Covent Garden. Turner attended his funeral.

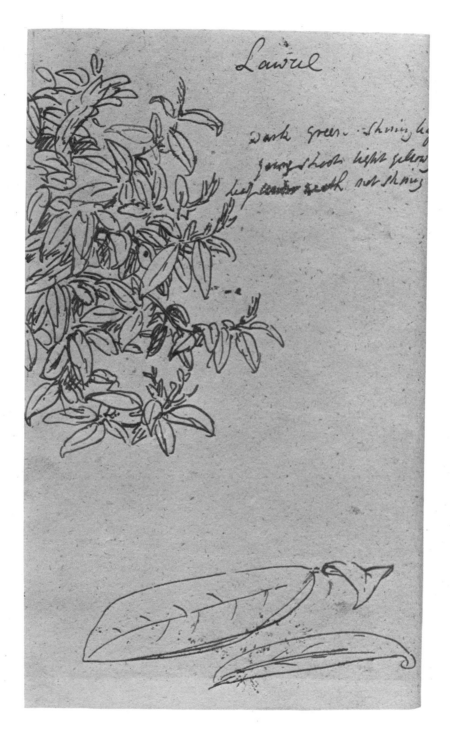

63 Laurel

endpaper. Cutter and other vessels with pennants flying

LXXI

Calais

As he lands on the French coast (adventurously, for his boat was nearly capsised) Turner has with him another of his pocket books, its paper previously washed with a tint suitable for chalk.

The sun is at his back as he stands on this new lee-shore and covers a few pages with lively, almost clownish, calligraphy. In this way he can best express his pleasure and excitement – with his favourite subjects, boats and waves. And, of course, they may be useful later on.

LXXI—19 a

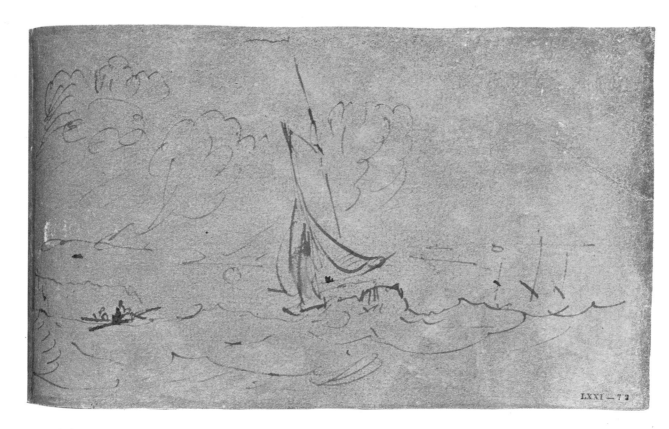

72 A brig

19a, 20

18a, 19

20a, 21

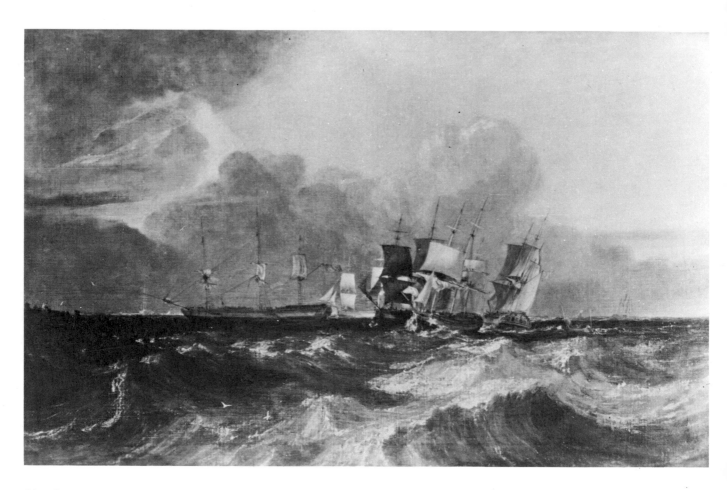

Ships bearing up for anchorage, painted 1801–2. National Trust,
Petworth, Sussex. The first of several Turners bought by
Lord Egremont.

Age		Tours in Britain up to 1802	Sketchbooks in the Turner Bequest	Subjects (approx.)	Some exhibited works
14	1789	Oxford			
16	1791	West Country	VI Bristol and Malmesbury	23	
17–18	1792–3	Tintern, Hereford, Canterbury	—	various drawings	1794 *Tintern Abbey* (Victoria & Albert Museum)
19	1794	Midlands, Llangollen, Shrewsbury, Matlock, Lincoln, Cambridge, Waltham	XIX Matlock XX Marford Mill	23 37	1795 *Marford Mill* (Cardiff) *Welsh Bridge at Shrewsbury* (Whitworth)
20	1795	Wells, South Wales, Pembrokeshire coast, Isle of Wight	XXV Small S. Wales XXVI S. Wales XXIV I.O.W.	32 83 45	1796 *Fisherman at sea* (Tate) oil *Llandilo Bridge and Dinevor Castle* (Cardiff)
21	1796	South-east coast possibly Lincoln	XXX Studies near Brighton XXX VII Wilson	30 63	1797 *Moonlight, Millbank* (Tate) oil *Ely Cathedral* (Aberdeen)
22	1797	Lake District, Derbyshire, Yorkshire, Northumberland, Tweed, Furness, Lancaster, York, Lincolnshire, Northamptonshire	XXXV Tweed and Lakes XXXIV North of England	89 95	1798 *Morning amongst the Coniston Fells* (Tate) oil *Dunstanburgh Castle* (Melbourne) oil *Refectory of Kirkstall Abbey* (Soane's Museum, London) *Buttermere Lake* (Tate) oil
23	1798	Malmesbury, Wye, Tintern, South Wales, Snowdonia Kent	XXXVIII Hereford Court XXXIX North Wales XL Dinevor Castle XLIII Academical *See* South Wales sketchbook (XXVI)	103 61 95 34	1799 Four oils which have been lost or are not available. *Warkworth Castle* (V & A)
24	1799	Lancashire (Whalley) and North Wales (Caernarvon). Fonthill	XLI Cyfarthfa XLII Swans XLV Lancashire and N. Wales XLVI Dolbadarn XLVII Fonthill XLVIII Smaller Fonthill	41 60 42 36 16	1800 *Dolbadarn Castle* (Royal Academy) oil *Fifth Plague of Egypt* (Indianapolis) oil *Caernarvon Castle* (B.M.) *Fonthill drawings* (Toronto and Whitworth)
24–25	1799–1800	Salisbury North Yorkshire, Durham, Tweed	XLIX Salisbury LII Guisborough Shore LIII Helmsley LIV Dunbar	22 36 68 88	1801 *Dutch boats in a gale* (Earl of Ellesmere) oil *Pembroke Castle* (Toronto) *Chapterhouse, Salisbury* (V & A)
25–26	1800–1801	Scotland Edinburgh, Loch Awe, Blair Athol, Stirling, Bothwell, Gretna Green	LV Edinburgh LVI Scotch Lakes LVII Tummel Bridge LIX Scottish Figures LXI Jason LXII Cows LXIII Colour Bill LXLV On the Cliffs LXV Composition studies LXVI Egyptian details LXVII On a Lee Shore 1 LXVIII On a Lee Shore 2 LXIX Studies for pictures	72 93 39 22 12 11 5 7 6 25 8 8 99	1802 *Fishermen upon a lee-shore* (Kenwood) oil *Tenth Plague of Egypt* (Tate) oil *Ships bearing up for anchorage* (Petworth) *Kilchern Castle* (Plymouth) *Jason* (Tate) oil *Fall of the Clyde, Lanarkshire* (Liverpool)
27	1802	Calais, on the way to Switzerland	LXXI Small Calais Pier LXXXI Calais Pier sketchbook (This is a large study book covering a longer period than is suggested by its name)	40 85	1803 *Calais Pier* (Tate) oil *The Holy Family* (Tate) oil

List of books

A. J. Finberg *A complete Inventory of the Drawings of the Turner Bequest* 2 vols, National Gallery, London 1909. Essential but out of print

A. J. Finberg ed. by Hilda F. Finberg. *The Life of J. M. W. Turner, R.A.* 2nd ed. Oxford University Press, London & New York 1961. The standard biography

Graham Reynolds *Turner* Thames & Hudson, London 1969 Abrams, New York. 176 illustrations. Available in paperback

John Rothenstein and Martin Butlin *Turner* Heinemann, London 1964. Braziller, New York. 202 illustrations

Jack Lindsay *J. M. W. Turner: His Life and Work* Cory Adams & Mackay, London 1966. Harper and Row, New York. 'A critical biography' providing much fact and local colour not obtainable elsewhere, and some speculation. 40 illustrations including some of the 'colour structures' – in colour. Full bibliography

Martin Butlin *Turner Watercolours* Barrie & Rockliff, London 1962. Watson-Guptill, New York. 32 very fine reproductions

The Farington Diary ed. by James Grieg. 8 vols, Hutchinson, London 1922–28

Sidney Hutchinson *The History of the Royal Academy 1768–1968* Chapman & Hall, London 1968

endpapers: pages from the 'Calais Pier' sketchbook LXXXI, 1800–1805 ($17\frac{1}{8} \times 10\frac{3}{4}$ inches, 43·5 × 27·3 cm)

Index